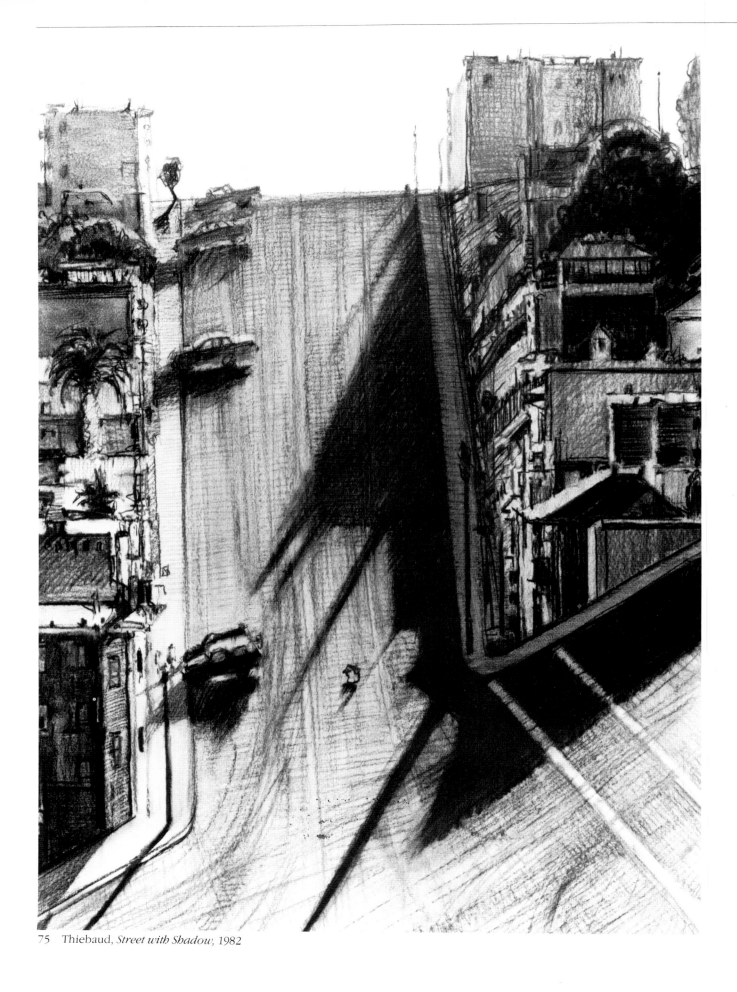

75 Thiebaud, *Street with Shadow,* 1982

Representational Drawing Today

A HERITAGE RENEWED

UNIVERSITY ART MUSEUM
SANTA BARBARA 1983

Exhibition organized
by Phyllis Plous

A HERITAGE RENEWED

2 March-17 April 1983
University Art Museum
Santa Barbara

26 June-7 August 1983
Oklahoma Art Center
Oklahoma City

21 August-9 October 1983
Elvehjem Museum of Art
University of Wisconsin, Madison

5 November-18 December 1983
Colorado Springs Fine Arts Center
Colorado Springs

Design/Production by Margaret Dodd,
Yellow Dog Graphic Works
Text type set in ITC Garamond Light by
Friedrich Typography
Display type set in Torino by
Lettergraphics
Printed in an edition of 1500 by
Haagen Printing & Offset

214860

University Art Museum

Photographic Credits

American Photocopy, Los Angeles
E. Irving Blomstrann, New Britain,
 Connecticut
D. James Dee, New York
eeva-inkeri, New York
E.A. Grenstad, Salinas, California
Helga Photo Studio, Upper Montclair,
 New Jersey
Darcy Huebler/Luciano Perna,
 Los Angeles
Bruce C. Jones, Rocky Point, New York
Learning Resources, University of
 California, Santa Barbara
Kevin Noble, New York
Douglas M. Parker Studio, Los Angeles
Sylvia Satner, New York

(Front cover)
27 Erlebacher, *Still Life Supreme,* 1979
(Back cover)
79 Valerio, *Tightrope Walker,* 1981

4

Contents

Lenders

The Fine Arts Museums of
 San Francisco, Achenbach
 Foundation for Graphic Arts
Mr. and Mrs. Peter R. Blum
Daniel Boley
José R. Bordes
Phillip A. Bruno
Vija Celmins
Dr. Jack E. Chachkes
Barney A. Ebsworth
Alfred M. Esberg
Allan Frumkin Gallery, New York
Forum Gallery, New York
Margot Gordon
Robert M. Halff
Stuart Handler Family Collection
O.K. Harris Works of Art, New York
Mr. and Mrs. David Hermelin
Hold'em Art Association, New York
Mrs. William Janss
Coe Kerr Contemporary, New York

Monique Knowlton Gallery, New York
Koplin Gallery, Los Angeles
L.A. Louver Gallery, Venice
Harry and Linda Macklowe
John Mandel
Mr. and Mrs. Richard Manney
Donald B. Marron
Dr. Thomas A. Mathews
Montclair Art Museum,
 Montclair, New Jersey
The Museum of Modern Art, New York
Mr. and Mrs. Walter Nathan
John Nava
Jay Y. Roshal
Sandra Mendelsohn Rubin
Mr. and Mrs. Steve Schapiro
Mrs. Robert Schoelkopf
Robert Schoelkopf Gallery, Ltd.,
 New York
Dr. Gerard L. Selzer
Sindin Gallery, New York

Ronald Sherr
Dr. Eugene A. Solow
Paulette Solow
Scott Spiegel
Staempfli Gallery, New York
Allan Stone
Wayne Thiebaud
Mrs. Gretchen Weiss
Edward and Melinda Wortz
Private Collections

Preface

It is a pleasure to introduce an exhibition that offers so many rewards to such a wide audience. *A Heritage Renewed* is one of those rare exhibitions that should satisfy at once the connoisseur of fine drawings, the contemporary critic, the teacher of studio practice, the art historian and — always important — the non-specialist museum goer. We believe this fine show will delight the eye of any visitor, while providing layman and scholar alike with a survey of an important movement in contemporary art — the revival of interest in descriptive draftsmanship.

The Museum's Curator of Exhibitions Phyllis Plous conceived and organized this exhibition with the assistance of Dr. Eileen Guggenheim, Lecturer at Princeton University, a specialist in the photo-realist movement, an important part of the phenomenon presented in *A Heritage Renewed.* It is not only an exhibition of beautiful and sensitively produced objects, but it brings home once again how varied responses can be to such a basic device as describing the world around us.

The University Art Museum has a long-standing tradition of presenting exhibitions that study important developments in contemporary and modern art — which this show continues, of course — but *A Heritage Renewed* seemed especially timely, and several other museums indicated a strong interest in sharing it with us. I want to thank Lowell Adams, Director, the Oklahoma Art Center; Katherine Harper Mead, Director, the Elvehjem Museum at the University of Wisconsin, Madison; and Paul Piazza, Director, the Colorado Springs Fine Arts Center, for participating in this venture.

J. David Farmer
Director
University Art Museum

Acknowledgments

This exhibition has been a happy combination of several ingredients. First came the opportunity to turn my attention to the much neglected subject of today's representational draftsmanship, the making of drawings that are both completely new as well as a celebration of something beloved from the past. Second, there was the generous cooperation of the artists, their galleries and collectors. Third, we had an enthusiastic response from the three participating museums as well as many other museums and art centers across the country. It was both exciting and pleasurable to investigate the major ideas that led to the formation of this particular exhibition with Eileen Guggenheim, who contributed one of the essays to the catalogue.

The twenty-two artists are included as a curatorial choice, limited by necessities of travel and space, rather than as a definitive selection of contemporary talents. The exhibition was curated by means of examining actual works through studio, gallery and collection visits where possible in this country. I am aware that representational art is flourishing in areas where travel was not possible. Also, to reach the point of selecting the works, an immense quantity of material — slides, photographs, catalogues, resumés and recommendations from one exciting artist that led to another and another — was reviewed and distilled. Even so, the final selection represents a very small percent of the overwhelming number of artists and works considered. As in other pluralistic periods in history, it seemed advisable to look at the work with an eye to its inclusiveness rather than its exclusiveness. What warrants inclusion in this exhibition is the sum of each artist's individual style, technique, iconography and, above all, the energy that animates his or her work. These artists have re-invigorated the tradition of representational drawing and, whether exquisite and delicate or powerfully gestural in their linear description, their drawing goes beyond mere academic considerations. Their works include conceptual, political and mythic elements as well.

The best collections of contemporary representational drawing in America have been formed by private collectors, not museums. Only now are museums beginning to collect in this area. Obviously, and yet

8

of the most signal importance, the willingness of the many lenders to part with their works has made this exhibition possible. Our deepest appreciation goes to them for their generosity and cooperation. The artists were very forthcoming with information, loans of works, and all the other sundry things that only the artist can provide. I am especially grateful to the following galleries and their staff who extended themselves for the sake of the exhibition: Jane and Robert Schoelkopf of the Robert Schoelkopf Gallery; George Adams and the Allan Frumkin Gallery; Phillip Bruno of the Staempfli Gallery; Sarah Mleczko of Coe Kerr Contemporary; Peter Tatistcheff of Tatistcheff & Company; Bella Fishko of the Forum Gallery; Carlo Lamagna of O.K. Harris Works of Art; Fred Marcus and John McCarron at L.A. Louver; Dorsey Waxter of André Emmerich; Geoffrey Parton of Marlborough Fine Art, London and Pierre Levai at Marlborough, New York; Helene Winer of Metro Pictures; Joan Wolf and Allan Stone of the Allan Stone Gallery; William Struve of the Frumkin Struve Gallery; and Marti Koplin of the Koplin Gallery.

For their suggestions early on in this project, both Dr. Guggenheim and I are indebted to conversations that took place more than two years ago with John Dobkin, Director of the National Academy of Design, and Barbara Guggenheim.

Special thanks go to Peter R. Blum, Frances Colpitt, Robert McDonald, Scott Spiegel, Peter Tatistcheff, Yoma Ullman for her critical reading of the Guggenheim essay, and Russell Wilkinson.

Finally, a large measure of thanks goes to those who lived with this project on a daily basis for more than two years. I was refreshed by Director J. David Farmer's enthusiastic recognition of the merits of this enterprise from the beginning and for providing encouragement at difficult times. Furthermore, he helped edit every bit of written material with keenness, precision, taste and astonishing good will. Student assistants Anthony Goddard and Leda Ramos assembled much of my initial research material with diligence and skill. Behind the scene, Registrar Alice Wong ranged far and wide with great efficiency, helping to coordinate the loans and travel plans for the exhibition's tour and gathering works from all over the country. In performing the handsome Santa Barbara installation and many of the requirements of the tour, Paul Prince, Designer of Exhibitions, was assisted by Brian Rutledge and David Cooper, all redoubtable exhibits specialists. With rueful cheerfulness, our far too limited office staff kept things moving while I was up to my neck in drawings. Susan Bernstein did a beautiful job of typing and collating the catalogue when permitted the time. Student assistant Mark Onstad showed himself to be a most capable typist and proofreader. Judy Altshuler with her usual gusto has done her accustomed job of providing information about the exhibition to all comers and helped to make the Santa Barbara events attendant to the exhibition a success.

Margaret Dodd, who recently formed Yellow Dog Graphic Works, dissolved all design difficulties with her customary aplomb and expertise. She has done a wonderful job on the catalogue.

Phyllis Plous
Curator of Exhibitions
University Art Museum

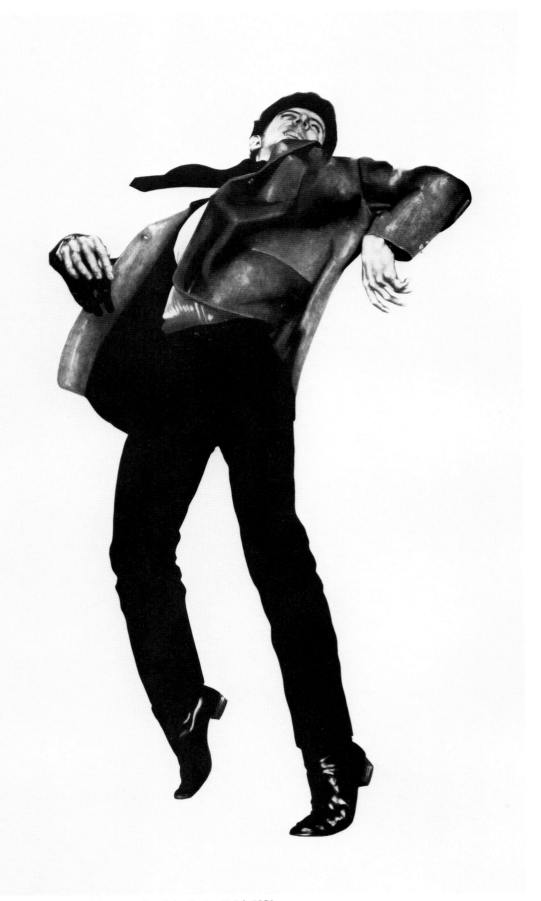

50 Longo, *Untitled (Men in the Cities Series: Eric),* 1981

Acute Perception

Phyllis Plous

One of the surprises of the last twenty years, a period of unusual expansion in art, has been the renewal of representational art. As an alternative to the reductive and regulatory strictures of late modernism, *A Heritage Renewed* presents one aspect of that contemporary phenomenon: the dynamic synthesis in drawing that stresses modern flatness with representational subject matter and traditional draftsmanship. Visual and intellectual power is the aim of the artists who practice it; elasticity and diversity are their characteristics. This kind of contemporary drawing has been independently generated by overwhelming numbers of artists who feel compelled to re-invent an approach to figurative art in our time. A responsive connoisseurship by

collectors and interest from the public are helping to restore representational drawing today to a position of consequence.

These considerations determined how our drawing exhibition came about and why it looks the way it does. To enlarge upon a moribund tradition that could serve up pleasing academic reconstructions did not interest us. You can't revive an aging pictorial practice — that's dead art on paper — but you can renew its aims and principles. We wanted to investigate the blending of tradition with contemporaneity. Upon examination, we found that tradition (a tricky concept) is a matter of broad significance involving a perception not only of the historical past but of its presence in our contemporary actions and experience. It is this historical

sense of the timeless and the time-capturing together that makes the artist (and viewer) more acutely perceptive concerning his own contemporaneity and alternative cultures in his own time.[1]

The will to form representational imagery is historic and irrepressible. It has endured since paleolithic times. Classical draftmanship retreated from contemporary art long ago, however, when stylistic advances in modernism and formalist criticism forced representation out of the mainstream. Since its renaissance, some of the best work that has been produced in representational art has been in the medium of drawing. It has been neither much exhibited nor much discussed. Instead, the literature has grappled with the notion of realism, one kind of

11

representation, as it is manifested in painting. Many realist painting shows had outstanding success with the public and were dutifully reported in the press. Realist painting, however, attracted negligible analysis, apart from the September 1981 issue of *Art in America,* which devoted itself to the subject of realism. Despite such neglect, realist painting, in one form or another since the mid-1960s, has had a conspicuous place in the art world, has remained in the public eye, and prospered in the marketplace.

Given the scant attention paid to draftsmanship by critics and museum curators, no real critical framework has been established for the varieties of representational drawing of this nature. Perhaps this is because its only consistency is the artists' determination to represent with vitality, and an edited accuracy, what is observable in immediate experience. Other than that, there is no unitary point of view on how or what to represent, no coherent set of principles and styles. This freedom of choice allows each artist to select whatever pictorial precedent he or she finds empathetic with his or her vision. Nevertheless, there are aspirations and attitudes that can be identified within the group. Many of the artists included in this exhibition concentrate on the process of empirical observation that culminates in a passion for definition. Several prefer drawings that answer rather than question. All of them pursue subject matter, but most of them, in examining the human situation, reject existentialism. For most, their personal tradition began in their relentless training in modernism, so the syntax of their art is based on modernist abstraction as well as on historical tradition.

Why is it so difficult to accommodate a manifest historical impulse for the re-invention of representational

drawing? We asked ourselves why it has seemed retardataire — a rebuke to contemporary art — when we, as viewers, encounter a finished drawing that reveals care lavished on the fine points of representational draftsmanship in company with some of the formal investigations of modernism. Given their rejection of other values we once prized in the modernist period, many of us feel nervous, even irritated, with this approach. The whole struggle of modernism seems to have centered on establishing an independent and autonomous context of meaning — a negation of the use of art for any purpose other than its own. Yet the repression and revival of the figurative in art reveal historical impulses that go far deeper than individual critical opinions. We are capable of recognizing that the long history of art for its own sake can be neither dismissed nor reversed by a simple decision.

Perhaps it is because in the 1960s a new critical public matured in our culture — a rich, large and increasingly powerful constituency that shared with many contemporary artists a distrust of the artistic as a category in itself. It also shared with radical thinkers an indifference to the benefits of historical continuity as we had cultivated it until then. A cult developed for the immediate, the casual, the unstructured, the transitory and, above all, for *change.* [2] Contemporary art of the 1960s had gained a new and important ally in its traditional attack upon the critical and custodial operations of the humanities. As this new aesthetic ideal developed, pluralism in art became acceptable to that public, although pluralism, as an explanatory term, never satisfied anyone. Representational art, always present in one way or another, was looked upon as hackneyed and old-fashioned. Relegated to the limbo

of philistinism, it was considered a "criminal" act in many circles.[3]

Today we are again cultivating our past traditions and our historical consciousness, and we support artists who do so as well. The moral universes of the past are different from our own, but that moral pressure or human concern, repudiated by the art of the 1960s, became imbedded in the art of the 1970s and continues in the 1980s. Since the late 1960s many younger artists perceived that they would garner public approval if they did something else. Despite their use of new materials and processes, artists began to delve into art history as well as contemporary non-art media — the distant and the recent — to establish links between historical consciousness and their experience of current culture. Whereas in the 1960s, artistic vocation had an aura of extroverted purposefulness — art was an exhilarating game of ideas — in the 1970s, it became imbued with hermetic concerns. Gradually an aura of almost tragic aspiration has returned and with it the desire for the benefits of historical continuity. Now we are involved with a catholicity of draftsmanship that has a literal bent, and we are less insistent on the premise that history decrees one style at a time.

■ ■ ■

Drawing as an art, following the Second War, lost its former structure, and technical mastery in the representation and expression of observed subjects disappeared. Traditional studies of draftsmanship, anatomy, the color wheel, etc., were frequently dropped from art school curricula, and drawing was used less often as preparation for painting. Two remaining sources for traditional training in New York were the Art Students League and the National Academy of Design, the latter allied with nineteenth-century

academicism. There were other schools, of course, spotted around the country, but they were few in number. Many of the artists included in this exhibition did not learn historical traditions of drawing in schools. They found their own way out of the domination of modernism through continual practice and from exchanges with other artists.

From years of studio visits, I know that such traditional gratifications of drawing never entirely lost their appeal for some of the best of our modernist artists — abstract expressionist, minimalist or otherwise. Many modernists, who had trained in traditional schools, continued to hone their ability to draw, and some acknowledged their adherence to the discipline of drawing from the figure or observable object on a regular basis in order to retain the skills needed for powerful linear description. Many artists reported that they could find nothing like the indescribable subtlety that is involved in drawing the human figure, the face in particular. Rather than allow their skills to lapse, they practiced drawing from the figure — sometimes daily, sometimes in groups, sometimes privately, even secretly. It is from them that I have learned what an enormous difference the slightest variation in a line can make. In this kind of drawing, a hair's breadth of difference in a line can mean the sacrifice between mainly an intellectual analysis of form or the visual power produced when the skill to observe merges with the talent to draw. Certain subtleties are necessary to convey the desired effect in representational drawing, and they require the discipline of constant practice. We have always had closet realists among us.

Drawing, whether modernist or representational, comprises much of the most serious and original art of recent years. Earlier, from Manet and the Impressionists onward, drawing's status had been de-emphasized not because of the failure of drawing but due to the nature of painting at the time. During the last twenty-five years, artists moved with increasing intensity to investigate the nature of drawing. As they questioned and re-evaluated the medium, both its context and its definition expanded in such a continuous and tenacious manner that today it stands as a major, independent medium rather than as a support for other media. As a process of interrogating what one sees in front of oneself, drawing is the exposed nerve of art. The artist's marks, the peculiarities of touch and line, and the manner in which he uses his arm, wrist and hand, are crucial. Drawing leaves the artist free to describe as ruthlessly and honestly as he can, but always with an implicit supposition that it might be rendered differently. So drawings can either ask questions or answer them.

Certain historical constants still prevail: contemporary draftsmen continue to use the bare essentials of notation and line for their realizations, sometimes adding chiaroscuro and color for distinctive expressive purposes. Usually they avoid truly elaborate processes used in painting or sculpture. Drawing still fulfills its two historical roles, serving either as finished works or as introductions to other more elaborate works. In this exhibition, the term *drawing* has been applied in its broadest sense to include paper support with pencil, ink, charcoal, watercolor, pastel, casein, etc.

． ． ．

Drawing of the persuasion that we find in *A Heritage Renewed* is not one thing but many things. In order to sort out value differences, clear distinctions need to be made among the community of ideas included here. The lack of clarity in this area has been a problem for more than a generation as historians, curators and critics have drifted back and forth between the terms figurative, representational and realistic, using them interchangeably in a confused semantic shuffle. In fact, the problem will be recognized in this catalogue where two different approaches to the exhibition's subject matter are discussed in each essay.

Whereas representation involves recognizable imagery, the term figurative connotes imagery that occupies space on a two-dimensional surface in a figure-ground relationship. Now, when formalist underpinnings support figurative drawings, figuration is no longer the aesthetic opponent of abstraction. For many contemporary artists, twentieth-century formalism has become indispensable to humanist expression, the intermediary through which the figurative artist can best structure and delineate his concerns.

Realism, fathered by Courbet and supported by the rapid advances of photography since the mid-nineteenth century, is meant to be a transcription of the real. It is willed work, incorporating two realities in one: the reality of the drawn surface and that of the carefully observed image. To make an accurate, detailed and recognizable translation of visual experience involves an act of acute perception, conditioned both in its content and its mode by time, place and concrete situation. As the ends are the only justification of the realist artist's means, realism equates with belief in the facts and the total content of belief itself.[4] The semblance of reality achieved by each artist is, to a great degree, a projection of that artist's preconceptions. In each case, the intended factualism of reality is altered as it is filtered through the artist's sensibility. When successful, realist

13

draftsmanship carries the value of an aggressively meticulous verism in its reportage that is anti-media in its sensibility. It simultaneously uses and denies photography. It is a physical language, one that catches an instant of perceived temporal fact and is more outwardly focused than representation.

A more inclusive term than realism, representation equates with *a picture of* and is more open to spontaneously edited forms of visual accuracy. An artist may suppress certain details in order to make a plea for attention to other detail. Representation carries with it a sense of direct confrontation and important ambiguities at the same time. When Douglas Crimp organized the exhibition, *Pictures,* in 1979 he advanced another measure of difference in value between realism and contemporary representation. Crimp argued that contemporary representation may go one step further and be understood as the only possibility of grasping the world of uncertainty that surrounds us now. It is not, therefore, relegated to a relationship with reality that is either secondary or transcendent. It does not necessarily achieve its meaning in relation to what is represented; rather its value lies in its relationship to the source of subject matter. In this way, representational art is freed from the tyranny of traditional representation.[5]

Historically, representation has been concerned with visual habits and patterns of behavior. Artists who evolved from the TV generation, perceiving representational imagery from TV and news media photography, utilize pictorial flatness and emptiness, the technique of non-space. Flirting with performance and film, they convey contradiction and uncertainty regarding the drama in which the figure is involved. Pictures of pictures employ traditional techniques — for example, the objectness of Johns' targets and

flags and the plastic conceptualism of Longo's subjects, which are representations of photographs. This kind of contemporary representation is a specific means to make yet another set of distinctions, separating out approaches and areas of interest.[6] Such artists adopt a seriously critical stance but shun the solemnity of an older generation in favor of ironic detachment.

Most drawings, like most artists' thoughts, result from a combination of analytical investigation and spontaneous emotional response. These two components have been defined variously throughout the history of art as classicism vs. romanticism, apollonian vs. dionysian, the rational vs. the non-rational, realism vs. naturalism, formalism vs. anti-formalism.[7] Representation can use a variety of conventions that are representational without indulging in confessional impulses. From its psychological content, the viewer does not necessarily infer indulgence in the narcissistic or heroic. It is art about personality but, all the same, it can be removed from self-expression if it chooses. In other words, although addressing effect and sentiment as in past tradition, contemporary representation accomplishes its aims by making art about cultural signs.

■ ■ ■

Draftsmanship denotes a whole set of skills — a way of drawing from which we infer the touch behind the technique, the speed and the pressure; a way of composition; a way of signifying; a way of notation; a disposition of pictorial elements; a way of cropping — all linked to the artist's choice of subject matter. In contemporary draftsmanship, both representation and realism rely on the polishing or mastering of

long-honored technical traditions to carry the spark of the artist's initial response to his chosen subject. Each of these draftsmen has re-negotiated the relation of the pictorial to the observable in his or her own way. Irrespective of style, however, there is an iconic fervency in their drawings. Their images carry their ideas.

The broader concerns that unite their works also serve to point out just how various they are. All the artists here have the capacity to disclose what they see and how they see despite each taking a different tack. As Rackstraw Downes remarked, "We're like a bunch of warring anarchists."[8] In combining discovery and imagination — reality and draftsmanship — each extends what he has observed, expressing a varying range and depth of experience. All of them use draftsmanship as a medium of confrontation rather than a support system for other media. In this last quarter of the twentieth century, when mass-produced visual imagery has begun to sap the photograph of its power as a medium of confrontation, we are encountering unique drawings by tough-minded and energetic artists whose subject matter, of necessity, evokes a reaction from the viewer no matter how objective the artist's portrayal. The directness and immediacy of fine representational drawing, the thoughtful suppression of certain detail (conscious or unconscious), in order to allow an eloquent appeal for attention, is the very opposite of the super-abundant photographic experience.

■ ■ ■

In the context of today's society, representational artists have to ask themselves what experiences society considers to be especially significant. Also, what images society attaches to

these experiences so that the experiences can be expressed.

In selecting this exhibition, we looked for mature artists who have continued to deepen and explore their art within a contemporary framework as well as mid-career and younger artists whose drawings reflect their place and time and whose images are emotionally compelling. All of the senior members of the group were using an abstract expressionist mode in the mid- to late 1950s. Personal dissatisfactions caused them to look to figurative art, and their use of memory and model as well as modernist structure combined to pull their new ideas together.

Wayne Thiebaud, a self-taught artist, spent his earliest years in theater work where he liked to control the overhead spotlights. From his vantage point above the performance and the audience, he saw the stage floor as a flattened ground plane on which actors and props were distributed in organized configurations. For him, light is the only means by which things exist, and perceptual confrontation is his first concern. Drawing, the primary impetus in his work, is crucial in terms of his thinking.[9] Thiebaud constructs from frugal means — depicting, from memory, single objects in stark isolation; a serialized group of objects as in *Five Hammers;* or, from the model, a basic figure against a bare backdrop, the posture motionless and unassuming. Whether objects or people, they exist in a vacuous, timeless space, divested of extraneous props. His still-life drawings read like tableaux seen from above, the table top serving as a stage to coordinate his objects and to define boundary edges.

There is a subterranean tension and elegant economy in the best of Thiebaud's drawings. Dealing with the ephemera of contemporary culture, he manipulates both planar arrangements and definitions of the commonplace. In *Caged Pie* (cat. no. 77) and *Five Hammers,* the observed objects are reduced to clear precise notations that contain an iconic power beyond their actual physical existence. In recent years, Thiebaud has concentrated a large part of his time on landscape forms and theatrical exaggerations of cityscapes. In the landscapes he accomplishes a spectacular balancing act between linearity and mass, and at the same time, creates a strangely nostalgic, dreamlike quality that approaches mysticism. *Street with Shadow* (cat. no. 75) confronts the viewer with a precarious state of tension. With telescopic vision, Thiebaud has developed a clearly delineated street intersection that distributes continuous waves of pure thrust, which sweep up the steeply arched streets as the shadows slant down. In a composition built on a geometry of interlocking shapes, the artist dissected both streets with smooth planar surfaces and street symbols. The simplified buildings, trees and figures, as well as the parked cars that don't look as though they would be able to stay on the plane and grip it, are referential points for the viewer's dizzying awareness of location in space.

A powerful image-maker with a distinctive idiom, Thiebaud's real subject is art. Despite the sensuous qualities of pastel and charcoal, the austere conditions of his drawings raise issues between generality and specificity, linear time and timelessness.

There are aggressive and contemplative qualities in William Bailey's classicized drawings, which separate his figurative art from the polemics of realism. Bailey's subject matter is his own metaphysical vision. But, as he is quick to point out, you can't strive self-consciously for the metaphysical. For Bailey, the central issue in his drawings is poetic form, and he sets out to reproduce what he knows rather than what he sees. During a conversation some months ago, Bailey compared his working method with something that the poet Wallace Stevens once said about wanting his own work to exist on an abstract plane but having to begin by talking about the weather. Cognizant that this is dependent on some sort of earthly grounding, Bailey is aware that he needs to set up circumstances that will allow for a poetic, rather than literal, possibility.

Bailey views both object and figure as abstract shape. In his commitment to abstract principles of formalism and the retention of objective imagery, there is a cool, analytical quality, a clarity and tightness, that corresponds to minimalism. When he began to experiment with the figure in the early 1960s he reports that, working alone, he didn't know at first that other artists were also trying to renew the tradition of figurative art. In Bailey's case, it's mind and memory — looking, remembering and forming by means of acute perception.

The style, scale and sensibility of his still lifes represent drastic changes in this historical genre, for he is involved with sophisticated, highly self-conscious concepts of modernism; new materials and processes; emblems and their schematic distortion. *Tuoro Still Life* (cat. no. 7) is dependent on props or models that he already responds to aesthetically and draws from memory, only occasionally glancing up. Rather than candid views with set up objects, all Bailey's still lifes are calculated, carefully balanced arrangements of qualified forms. His first consideration in beginning a drawing is size and scale, and he changes the proportions of those familiar emblems to suit the scale of the drawing. Decorations, handles, etc.

may disappear as he stretches, pushes or pulls his weightless forms, but the objects remain because the artist wants a geometric specificity of vision in his finished work. Bailey places emphasis on flatness by means of frontality; on hard contours of objects that overlap yet seem not to touch; and on sensuous, eclectic shapes against stark, stripped backgrounds. He is concerned with presence, intervals of space and the rhythmical manipulation of light, and he remains indifferent to the topical in art, to time or place. If there is a message in his iconography, it is that he thinks in terms of architecture. His still-life forms compare with the precise, immaculate drawings of industrial buildings that caught the eye of Demuth and Sheeler in the earlier twentieth century.

When drawing the human figure, Bailey begins by working from the model, but the time he allows himself is brief. Perhaps two hours, no more, never again. The real drawing develops after the model is gone. Here he is more indulgent with respect to sensual and psychological content than in the purer still lifes. He designs expertly, indicating the spiritual isolation of his subject by inserting the figure into a large area of minimally articulated space. In *Untitled Nude* (cat. no. 6), a demonstration of his technical mastery, the subject is calm and composed, her distant gaze indicating absorption and preoccupation with her own thoughts.

On the surface, Bailey's representations seem easily accessible. In his exploration of psychological structures and meanings and his use of memory, the works are actually rather distant and difficult of access.

Because R.B. Kitaj left America in his twenties to travel and study in Europe and England, where he has remained, his work is more widely known and accepted abroad than here. When Kitaj

left Oxford to study at London's Royal College of Art in 1960, many of the most talented students there were reluctantly doing abstract expressionism. During his first weeks there he began an enduring friendship with David Hockney. Joining together, they and several others at the school who were seeking refuge from abstract painting as existential autobiography, a concept formulated by critic Harold Rosenberg, began to demonstrate that a new kind of representational art was possible. Kitaj spent two years drawing in the Royal College's life rooms.

Kitaj's earlier works reveal ways in which picture-making could be a vehicle for intellectual as well as sensual communication. A literary scholar as well, he viewed image-making as the construction of a language of signs that could be read in the way that words can be read. In fact, it was Kitaj who seems to have shown Hockney the ways in which literature could be used as a legitimate source of imagery. Never actually a Pop artist, it was Kitaj's fragmented, cartoon-like style and new use of materials that confused the critics. His process of picture-making, one that incorporated several phases of modernism, included provocative juxtapositions of images with diverse origins and associations, collaged and photomontaged onto the surface of the work. Given Kitaj's social and didactic intent and his ability to organize his pictures with dramatic and psychological coherence, he was making drawings, paintings and prints that were like story-telling or a theater of images.

In 1973, Kitaj first ventured into pastels and since then he has become increasingly interested in drawing from life. He makes intense life-studies, working them in a patient and perfectionist way. The drawings, all made without sacrificing originality or

contemporaneity, recall both old-master draftsmanship and figures from political mural painting of the 1930s as in *Sixth Avenue Madman* (cat. no. 41). Each drawing is done on heavy paper with firm outlines in pencil or in charcoal which is then rubbed and caked with pastel. His use of contour lines (they seem to swell as he searches for the form) are the basis for the critical decisions he makes. Form, weight, feel and impetus seem to be grasped all at once.

Kitaj has said that only when young artists go the *tough* route, learn to draw well again and become "suspicious readers," will a social poetics of art make it anew.[10] His drawings invite the viewer to attend to the nerve of his subject matter which, for him, means representing people in their concerns and in their plenitude. The recent work has a two-fold rationale: gifted draftsmanship and intelligent observation of what the twentieth century has done to human beings. Kitaj's singular drawing, formal achievements and use of subject matter separate him from the pack, placing him among the leaders of resurgent representation.

David Hockney shares several links with Kitaj, not the least among them a characteristic voyeurism. Yet his omnicompetent drawings reveal a very different sensibility. Hockney's work is a curious combination of serious and sensitive draftsmanship with a crystalline style uniquely his own. Powerful virtuosity, intelligence, mordant wit, sensuality, learning and a certain petulance are the ingredients that bind a Hockney drawing together. His portrait sketches may be tender as in *Maurice Sleeping,* cool and slightly comic, crisp and detached, or a sensitive tribute as seen in *Sir John Gielgud* (cat. no. 37). *Hotel Room, Hot Springs, Arkansas,* a portrait without

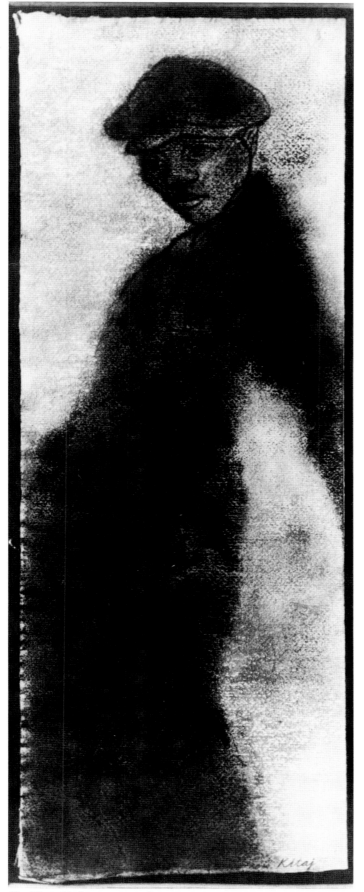

41 Kitaj, *Sixth Avenue Madman,* 1979

people, expresses personal loneliness with poetic power. Usually he excels in black and white and small scale, but the remarkable effects Hockney has achieved in works such as *Study of Water, Phoenix, Arizona, No. 14* (cat. no. 34), using vibrant color to represent light and water, are a technical accomplishment of considerable originality.

Hockney's line, economical and sensitive to the smallest nuances, almost (but not quite) gives the lie to his scavenging and additive processes with respect to modernism. Captivated by cubism, and involved with, but less tolerant of, abstract expressionism, he has consolidated modernism's formal concerns while re-introducing the personal, the emotional and the humanely felt. Hockney is an intimist of extraordinary persuasion whose works express a vernacular urban culture, which he treats with a sense of irony and wry cultural commentary.

Alfred Leslie is represented in the exhibition by graphite works that, in grisaille, underscore his preoccupation with the defining powers of light. Like Thiebaud, Leslie uses an iconic centrality and the familiarity of homely details. There the similarity ends. Regarded in the late 1950s as one of the leaders of the second generation of abstract expressionism, he worked out systems to structure his sweeping gestural style. Early in the 1960s, Leslie began to investigate a new kind of pictorial structure, one that relies on some modernist values, the grid for instance, while adding a hard, precise recording of things or events seen on the spot. There is a heroic solemnity in Leslie's powerful realist drawings that, as Robert Rosenblum has pointed out, discloses Leslie's dialogue with old-master drawing and painting and a constant consultation with the past.[11]

In the stark *Self-Portrait of the Artist*

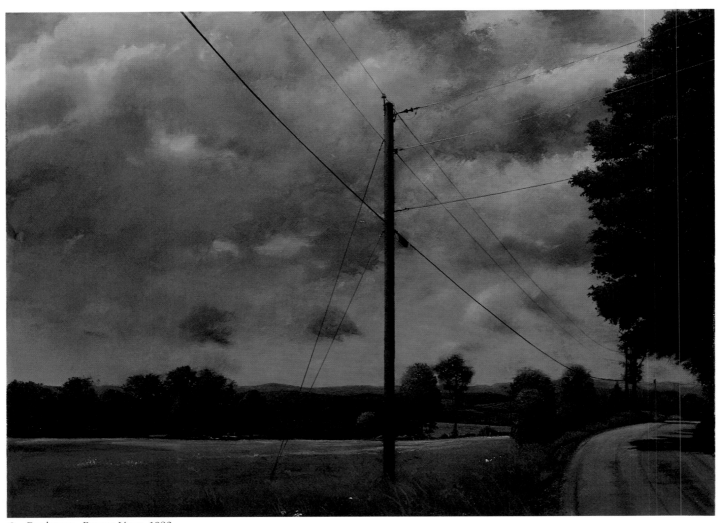

9 Beckman, *Power Lines,* 1982

in his Studio (cat. no. 43), the viewer is confronted with an intense realism based upon the artist's documentation of his daily experience within a specific time, place and social milieu. In his drawing called *Preparatory Study for "In the Studio of Gretchen McLaine"* (cat. no. 44), he reveals the imperatives of a homely, almost desperate realism. Eloquent, energetic and profound, here Leslie has depicted painstaking details of characterization without sentimentality.

Clearly rendered and candid, Vija Celmins' investigations of the surfaces of galactic views, desert floors, the ocean and snow are grounded in real experience and description, yet transcend those realities. She has re-negotiated the relation of the pictorial to the observed in her own

particular way so that her reductive drawings work on an abstract and a literal level. In *Untitled, Snow Surface* (cat. no. 15), the artist is concerned with a passage of time, infinite space and the mutability of her subject matter.

The longer the viewer concentrates on one of Celmins' surfaces, where each small stroke of the pencil brings another portion of the "real" image into existence on the picture plane, the more he becomes aware of an abstract presence, random and without motivation. *Galaxy, Cassiopeia* (cat. no. 12) is a visual transcription of an instant in the life of a world that existed.[12] By means of her intricate linear detail, elimination of scale references and a blurring of distances, Celmins succeeds in conveying the fullness and emptiness of an elusive, metaphysical world.

Rackstraw Downes begins a drawing on site by tacking a piece of paper to a drawing board. Then as he turns his head to study the scene, he expands, adding a sheet to the left, then to the right. Usually his drawings are emphatically horizontal, made up of two or three or more components. In *Looking up 107th* (cat. no. 21), several sheets of paper can be discerned, pasted together into a spectacular view that tilts and presses outward. Downes has cut off the possibility of deep space and opted for the flatness of modernism. The decisions in each drawing that can be found by the viewer are hammered out with a preference for an unrestricted peripheral vision. Whether a vision that goes back to American primitive painting, which he likes, or a vision that predates the one-point linear

perspective of the Renaissance, Downes' wide-angle views (see *The View South from Washington Bridge on the Harlem River* (cat. no. 23) come from straight perceptual means and are not influenced by the camera.[13]

Downes' panoramic views of Manhattan cityscapes and Maine's rural workscapes express the passage of time and the mutability of the terrain of specific contemporary locales. Small in size and composed with a wealth of detail dispersed across the surface, the precise appearance of his drawings, including some of the social dimensions of each locale, represents a slice of life shaped by the artist to get the desired reverberations. Although he deals with the traditional subject matter of landscape, Downes is very involved with today's polluted conditions and man's interaction with his workaday world. It is his approach to spatial problems, his editing, which is sometimes as radical as it is discreet, and his search for the interaction of idea with material that lift his compositions out of illustration into metaphor. This, of course, is the energy that animates Downes' drawings.

The landscapes of William Beckman reflect the interaction and consequent modification between man and a working rural environment. The darkening sky of the pastel drawing *Power Lines* (cat. no. 9), dominated by an approaching front, invites comparison with seventeenth-century Dutch landscape painting. Beckman is not interested in nineteenth-century American landscapists and prefers to look to Constable and Ruisdael. The viewer will recognize this in his adherence to visual specifics, his use of the horizon line as a compositional spine from which land and sky unfold, and his depiction of transitory light and changing weather. His use of landscape recession in *Power Lines* also hints at psychological space as well as architectonic space. By inserting twentieth-century technology and machinery into his landscapes, Beckman sets up internal contradictions in their composition. His technically rigorous yet gentle pencil studies and his muted pastels of rural workscapes are accurate reflections of his selected subjects — farms known intimately from

Beckman's solitary, daily running along country roads near his home, followed by periods spent drawing on site in his pick-up truck.[14]

Beckman makes spare, linear portraits as well that are strikingly personal and contemporary. In *John Deckert* (cat. no. 8), a life-size frontal nude, Beckman worked from the model using charcoal for the values he could achieve with it. The artist also used a string grid in front of the model, as is his custom, to plot the drawing. The viewer is immediately aware of the artist's meticulous observation and insistence on correct proportions. To compensate, however, for flattening the figure against the plane, Beckman has rendered it a bit stockily.

Gregory Paquette and Akira Arita are scrupulous and aggressive realists who describe commonplace forms and textures in terms of black and white value contrasts. Paquette makes interiors, landscapes, portraits and still lifes. In contrast to Arita, his subjects seem more than personal although their presentation is not narrative. In *Attic III* (cat. no. 66), Paquette is closer

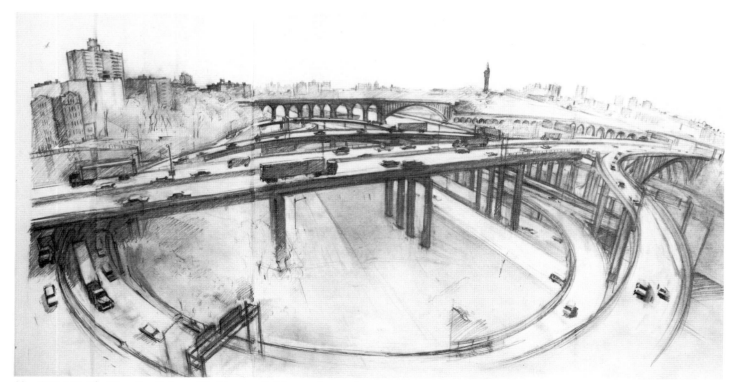

23 Downes, *The View South from Washington Bridge on the Harlem River,* 1982

19

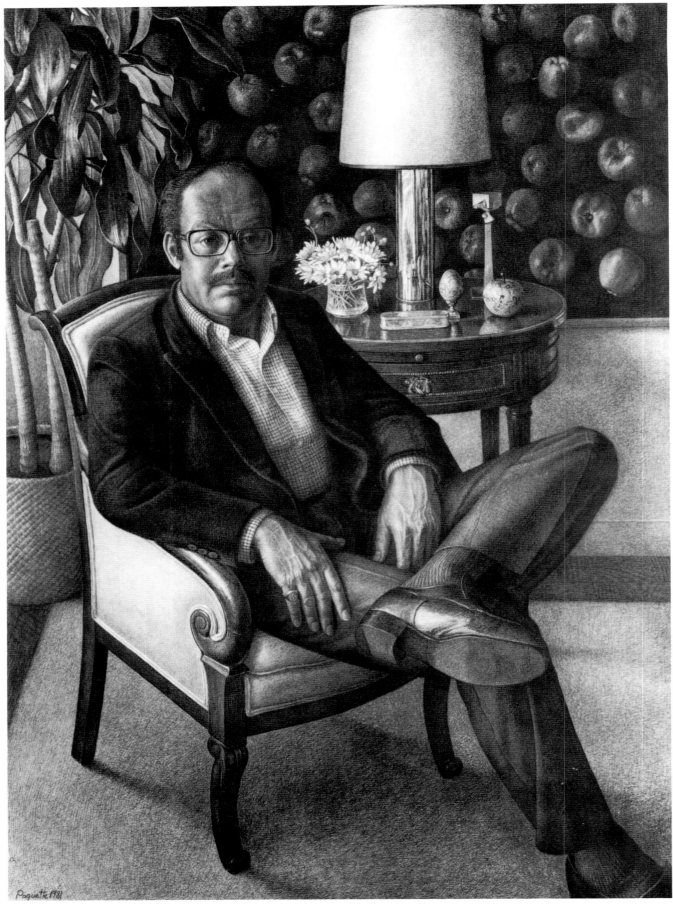

64 Paquette, *Portrait of Phillip Bruno*, 1981

to autobiography and metaphor than abstraction whereas his richly detailed *Portrait of Phillip Bruno* (cat. no. 64), in which he uses direct descriptive notation, aims to express a particular personality with an edited accuracy. The artist has clearly made certain decisions about how much he intends to say about his live model and how much he intends to hold back.

Arita's drawings seem less personal yet his still lifes of geometric forms, set against patterned and stained acetone backgrounds, suggest the soft and the sensuous. In *Still Life with Architectural Fragments* (cat. no. 1), Arita uses the still-life tradition endemic to the plastic arts to emphasize abstraction through relationships of scale and figure to ground.

Ronald Sherr, an exceedingly fine draftsman, reports that his preference for meticulous realism was formed by his response to identifiable images. In *José* (cat. no. 72) and *Betty's Babies* (cat. no. 73), the meaning lies in the artist's personal interpretation of his subject, the emotion behind his perception, and his decidedly humanistic approach.

Both Martha Mayer Erlebacher and Gregory Gillespie make penetrating drawings that refer to conventions that predate modernism, specifically the northern Renaissance. They share an authority that puts the viewer in touch with essence even though that essence may be enveloped in surface familiarity. Of the two, Gillespie's personal vision is the more eccentric. There is a chilling quality in his meticulous detail with its measured degree of modernist simplification. Still his reserve seems to break when he confronts his own brooding image. In the disquieting self-portraits (cat. nos. 28 and 29), Gillespie's introspection and technical skills

transform a realm of formal, intellectual and psychological interplay into a fabric of human anxiety.

Erlebacher draws female nudes and still lifes, injecting a disturbing symbolic content into her realistic illusionism. Her remarkable technical proficiency indicates a study of anatomy. The hard treatment of line and frozen sensuality of her nudes is rendered with a clear eye toward a northern sensibility — dour, moody, ascetic and difficult. *Face* (cat. no. 25) has a remote quality and a cold eroticism that places its subject right in the end of the twentieth century.

Still life lends itself to the strictest control of pictorial space and admits the smallest margin of psychological or literary association. In *Still Life Supreme* (cat. no. 27), Erlebacher combines very specific details of visual perception with strong abstract design to make the drawing feel contemporary. The spatial environment is abstract while every detail of the objects is studied with an authoritative precision and density. The table surface is tilted to fill the picture plane, the objects settling firmly into their assigned places.

The use of the photograph as source material for drawing notation has been with us since the mid-nineteenth century. John Mandel makes very generalized photographs of his posed models in order to portray a narrative essence rather than the model's particularity. He directs a fictional pose for his models and, from photographs that are neither remarkable nor artistic, he begins the creation of a mute narrative content for drawings that provoke but offer no answers. Mandel's drawings are caught between two worlds: conceptualism and tradition. Long a brilliant draftsman, in recent years he has de-escalated his obsession with rendering in order to reach a complexity beyond rendering alone.[15]

Photographs, for Mandel, are maps, and in *Untitled* (cat. no. 55) the artist takes what he needs from the photograph, then superimposes freehand, gestural drawing over his careful rendering. These overlays of freehand pencil marks, lying on the surface and synchronous with the picture plane, create a tension between the two-dimensional and the three-dimensional, emphasizing the artificiality of illusionist space and cancelling it out. Mandel's sensuous drawings suggest a full awareness of alternative modes of feeling.

David Ligare is concerned with the transient quality of life and an aesthetically distant view of the human experience. Because he prefers late afternoon sunlight to emphasize his meanings, a light that doesn't last very long, the use of a posed photograph is of great advantage to his non-narrative method. Ligare, whose drawings are begun with preconceived restraints and limitations, makes representations that avoid the qualities of nineteenth-century realism. He also avoids the kind of photographic surface that viewers invariably associate with photo-realist drawing and painting because he finds there is too little content in such work.[16]

The drawing *Et in Arcadia Ego* (cat. no. 47) is like a marriage between ancient Greece and today's Salinas, California. Man's transience is emphasized in the contemporaneous quality of a set-up of the photograph of a posed male model, a plywood form representing a broken stele, and the unmistakeable landscape of the Salinas foothills replacing our idealized sense of ancient Arcady. Ligare's consummate draftsmanship introduces a sophisticated modern enactment in space with simple figure-ground relationships. His small-scale, classicized drawings are contained and

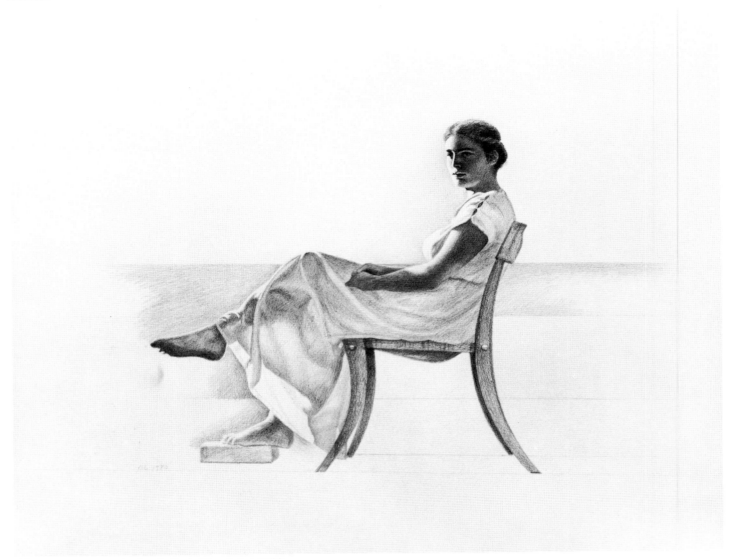

46 Ligare, *Woman in Greek Chair (Penelope),* 1980

at first seem intimate. There are no deceptions and nothing is hidden, but Ligare's realities are idealizations crossed with twentieth-century overtones. Space is rendered paradoxically, so that the viewer is simultaneously invited into and precluded entry from it. The event of each drawing is central yet extra-temporal in the sense that all action seems suspended. Mimetic and metaphorical at once, Ligare produces imagery that may appear eccentric to the viewer who regards representation only in terms of the realist tradition.

D.J. Hall and Robert Cottingham operate within a lived experience, in critical form, of consumer society. With experimental objectivism, they use the camera for reference, snapping subjects that are later altered in the studio. While memory and nostalgia come in and out of focus in both their work, on a formal level Hall is concerned with color, light and flatness. She portrays people, especially women, in carefully chosen settings and the two together make up her subject matter. In *Too Pretty to Worry* (cat. no. 32), the most recent drawing among the three in this exhibition, Hall made extreme distortions and exaggerations from the photograph. She works in the background first, her customary procedure. Moving toward the foreground, the underwater area reveals elegant renderings as well as an involvement with color and light directly on the surface. Hall's pencil strokes are predominantly vertical with a diagonal slant toward the left (she is left-handed), although the viewer can discern horizontal and rounded strokes in the brim of a very red hat. Hall builds up layers and layers of color with Berol color pencil, going to the faces last. Skin is of enormous concern in her nontraditional portraiture that deals, in minute detail, with the psychological problems of youthful expectation and the process of aging in contemporary society.[17] The figures that Hall draws are far more intensified than on the photographs to which she refers, and one senses the love/hate relationship the artist has with the people she portrays.

Thiebaud and Rosenquist made Hall want to be an artist, especially

Thiebaud. A member of the first television generation, TV imagery is an important influence on her work because of its constant confrontation with realism. Hall, however, rejects the lack of emotional care and content in TV production. She sifts photographic appearance through an emotionally charged drawing sensibility.

Cottingham travels across the United States, selecting subjects in shabby, commercial areas, which he photographs for use as reference material when working in his studio. In his drawings, he presents cropped glimpses of architectural landscapes — letter forms, signs, store fronts, marquees and building façades — which emphasize the textural details and differences an urban pedestrian might encounter during a walk.[18] Cottingham's visual images are much smaller than life yet give the viewer an impression of literal monumentality. Despite his use of photographic imagery, Cottingham's clear, hard edges slice space and form shadows, giving less an effect of realism than abstraction as in *J. C.* (cat. no. 17). His formal designs represent extreme alterations of the photograph and can be read on more than one level. Taut and succinct, the black and white drawings are a composite of line and form while the watercolors add a third element of color. His subtle use of spatial configurations result in works composed in depth, albeit a shallow depth nearer to cubism. Cottingham offers the viewer a heightened sensitivity and shared sensibility toward the American real of the 1930s to the 1950s, together with a strategy conceived in Duchampian irony.

James Valerio works from photographic transparencies, lingering over details with acute precision. The transparency, according to Valerio, functions as a window to realism, allowing him to contemplate the world at his own pace as he thinks out the images and ideas for drawings. Occasionally he borrows images from several transparencies. Working from a group of them, he says, is like putting a puzzle together.[19] Valerio, however, allows a tension and mystery to intrude

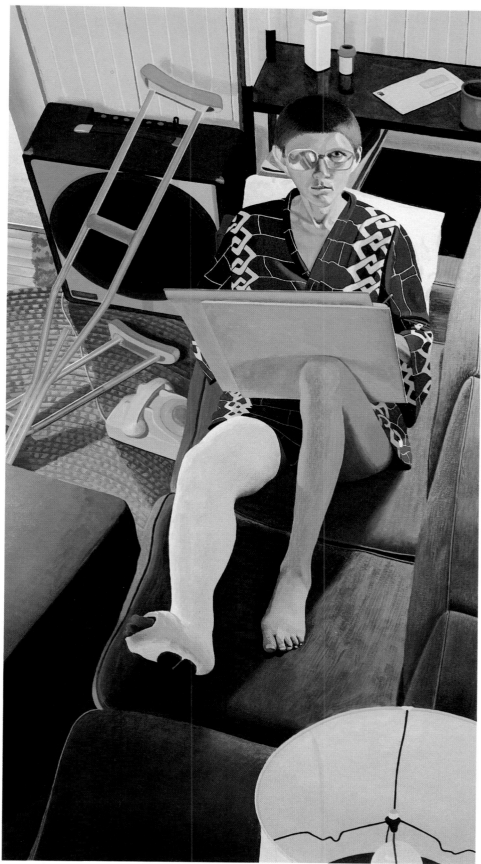

70 Rubin, *Artist with Broken Leg,* 1982

23

in each of his drawings and succeeds in incorporating humanism within his technical approach.

In *Study for Differing Views: Interior* (cat. no. 78), the viewer recognizes familiar looking people poised in mid-gesture and acting out private behavior patterns that leave them virtually oblivious to each other. Their solitary boredom, reflected back to them through bare, night-darkened windows, is underscored by an intense light that does not cast shadows so much as it accentuates the chiaroscuro of the folds of skin, clothes and patterned rug. Valerio's harsh contrasts let the figures dominate the space. The strange poetic sensibility of *Tightrope Walker* (cat. no. 79), a portrait of extreme tension, involves fine vigorous draftsmanship. Its strength lies in its ability to draw upon the resources of the representational function without relying on the easy evocation of a world beyond the drawing itself.

By contrast, Sandra Mendelsohn Rubin prefers to work from life, drawing on site or from set-ups, with a concern for the light, the smell, the mood and the tactility of her subject matter. Using the plane of her paper sheet to work as the plane of her image, her still-life drawings are equally edited and composed for psychological effect as her cropped and condensed *Self-Portrait* (cat. no. 67). In still life as in portraiture, Rubin's subjects come from a close observation of natural forms. Along with her drive to simplify and concentrate form and her skilled draftsmanship, she employs naturalistic color. Rubin's drawings, besides being read representationally, can also be read abstractly or symbolically.

As the underlying concern in Rubin's drawings is to capture a certain quality of light in order to create a mood, she feels that her use of life drawing allows her a use of all the senses and a full range of information to select from and edit. Rubin focuses on her own vision and what her vision can handle, a very different process than the use of photographic reference.[20]

For *Artist with Broken Leg* (cat. no. 70), a drawing that radiates instant visual power, Rubin used a mirror on the ceiling to achieve the angle of vision and perspective that she wanted, thereby emphasizing the large element of aesthetic artifice on which representational drawing is based. Because her sense of structure is so lean and legible, her graphic concision, with touches of color, seems to coax light from the white surface of the paper, giving it a special force.

John Nava's interest in the figure is a more or less straightforward one that refers to the compelling nature of his subject, the psychological encounter of drawing from the model, and the process at work in making his pictures. Nava is much concerned with the time involved in looking and drawing. His images, sometimes constructed from separate drawings (separate moments), are brought together to assemble a whole. However, the illusion in the picture is left discontinuous so as not to mask the accretion of drawing or of different kinds of marking and meaning. In *No. 5* (cat. no. 63), Nava has used acrylic in his background as a color change to influence the space but not as an attempt to model his figures or interfere with the pencil treatment.

Another member of the first television generation, Jody Mussoff stands on the other side of a monumental cultural shift, drawing upon material that is the fabric of everyday life in the 1980s as *Woman Fixing Girl's Hair* (cat. no. 60). In cool, punk drawings, she assimilates the psychological realism of the new wave as she pictures life among her friends.

Mussoff sets up a dialectic between high art and popular culture with an edited synthesis of contemporary vision and emotions that are vulnerable to the time in which she is living.

Is *Untitled (Men in the Cities: Eric)* (cat. no. 50) by Robert Longo the picture of a male figure falling back because he's been tripped or mugged? Has he been shot? Is he a rock musician, perhaps, or could he be doing a punk dance? Despite checking back and forth, the viewer can't fix on an answer. Longo's work raises questions of meaning and, in the long run, the uncertainty he creates becomes a matter of viewer interpretation. By presenting what is really a picture of another picture, Longo is bringing potentially — even violently — contradictory urges of tradition and innovation into his work. Inventive and conservative, contemporary and historical, the iconography and underpinnings of his work reflect their sources in other media as well as art history. Longo presents images from the culture at large such as film stills, TV images and performance pieces (he himself is a performance artist and sculptor and choreographs for a rock group as well), in addition to using indirect models from photographs that he has directed.

Longo's drawings are precisely rendered on a stark white ground that reads as non-space. In their isolation, the figures appear to have the thinness of cut-outs, seem larger than life (some actually are), and take on an iconic quality. As Jeanne Siegel has written, their clothed bodies, caught in a variety of arrested motions, suggest a kind of agony.[21] In the *Men in the Cities* series, single male figures are dressed in the symbolic costume of urbanism — dark suit, white shirt, dark tie. Longo's images manage to encompass both the high style of new wave and the

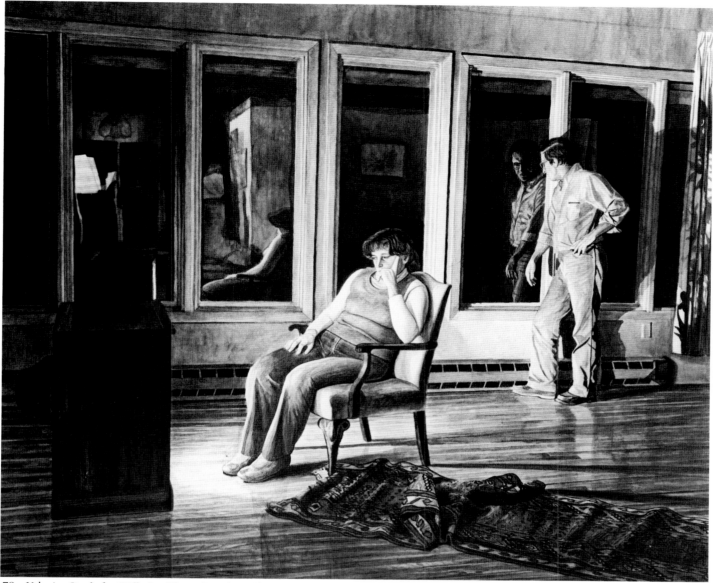

78 Valerio, *Study for Differing Views: Interior,* 1981

everyday look of an IBM executive.

Much of the execution of Longo's work is delegated to assistants (the Longo workshop), a practice that has several precedents in history from old masters to minimalists. Longo begins the drawings, supervises their execution, and completes the finishing touches or alterations that he wishes to make. In this process, he and his assistants continually borrow movie-making techniques such as props, angles, cropping, lighting and editing — manipulations that are themselves contemporary.

Jarring and dislocating, Longo's figures bind us to our present situation and challenge our traditional desire for control of human experience.

▪ ▪ ▪

While criticism may be as inevitable as breathing, the congeries of styles and counter-styles of representational drawing today has little critical structure or theoretical support. Since its renewal some twenty years ago, the span of a generation, representational draftsmen continue to be more disadvantaged by the prevalent climate of critical opinion than they are by the climate of public opinion. There is no serious articulation of the means by which we link our experience of individual works such as these to our understanding of the values they signify. Clement Greenberg, one of the more systematic and distinguished critics of the twentieth century, has noted that art criticism habitually lags behind art; and most of the things that get written about contemporary art belong to journalism rather than criticism properly speaking.

One of the reasons, of course, for this paucity of criticism is that our age is jamming up. Confounding most critics and historians of this last generation is the irrefutable fact that there are really too many artists, working too fast and reproduced too widely, for historians

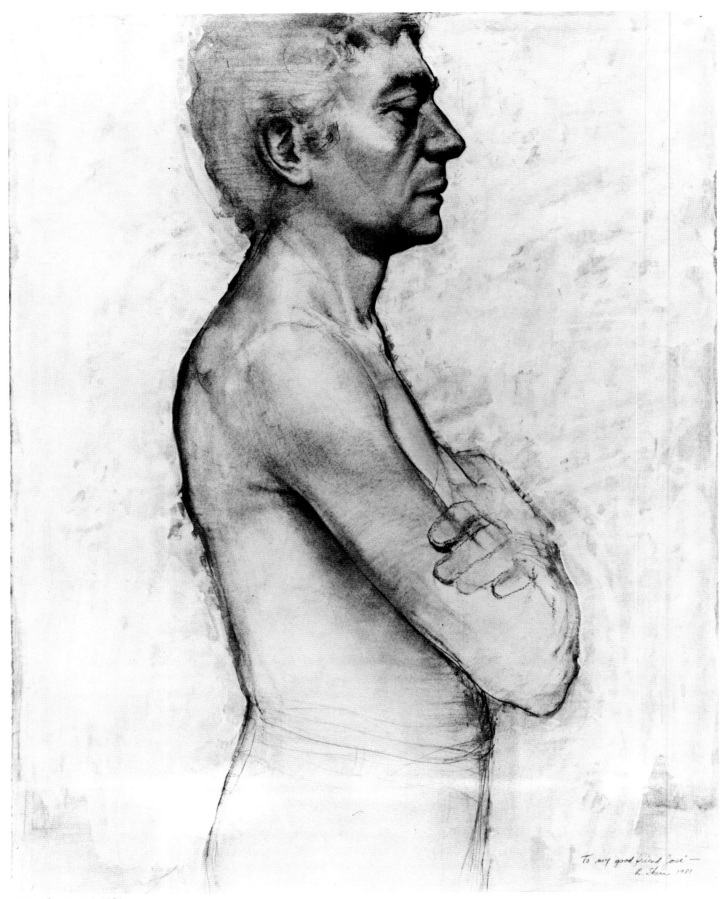

To my good friend José —
R. Sherr 1981

72 Sherr, *José,* 1981

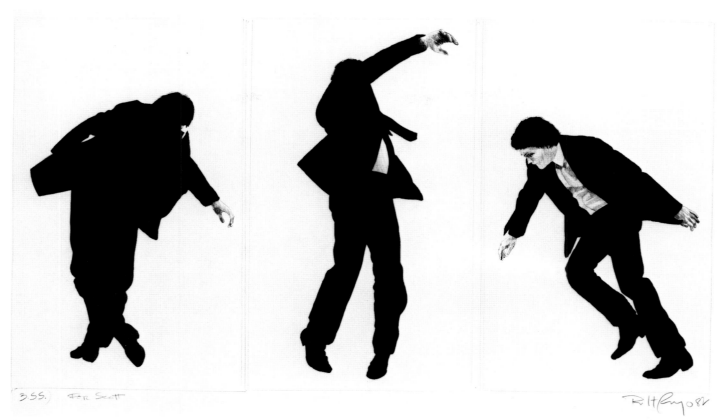

51 Longo, *3 S. S. (For Scott),* 1982

and critics to keep track without crowding them together into conveniently labelled packages in which only the most unoriginal and repetitive among them really fit. Criticism too often becomes like a giant sorting machine, pigeon-holing and then reporting art. Nonetheless, representational drawing demands plain language and intelligent critical insights that will illuminate the pictures, the intentions and the values of the artists who make them.

These artists need critics who no longer limit themselves to formalist doctrines that eliminate background and foreground, inside and outside, up and down. They want critics who, on the one hand, can cope with styles and structures of pictorial representations that may include such older values as unequivocal illusionism, literal iconography, a strong sense of frontality or directional axes — all within a contemporary sensibility that includes aspects of modernism. As it develops, this same critical language or structure will also have to make distinctions within representation, identifying new sources, values and ideals that come from connections with other contemporary media. Critics of representational drawing will need to search out and make use of its characteristic methods in order to criticize representation itself, not in order to subvert it but to entrench it more firmly in its area of competence.[22]

Examining the structural roots of such a heterogeneous group of styles in depth and acknowledging the vital synthesis that occurs in the making of representational drawings may be a first step toward the necessary language and structure. Viewers who look with care will judge that the expressive strength of works of this nature comes from the ability to draw upon the resources of draftsmanship, objectness and subject matter while refusing to traffic in fiction beyond the boundaries of the drawing itself. Rather they will look for the ability to evoke the general through the particular in images that reach beyond the moment and into the collective consciousness. They will find that the modernist influence, like some obsessive retrieval system, is fashioning the formal structure of such drawings. Abstraction, it seems, has become indispensable to human expression, the vocabulary through which representational artists can best delineate current didactic themes. What we had long professed to admire in modernist art — its freedom from nonaesthetic issues and political issues — has also been a source of difficulty for those who believed that modern art was forfeiting its responsibility to communicate, to record history, and to serve as witness. Now that the whole idea of the avant-garde has been jettisoned, it is possible to join the reality of insight with the reality of sight.

Critic Leo Steinberg, in *Other Criteria,* voiced his strong disapproval of contemporary formalist criticism as long ago as 1972 when he noted that only those innovations will be significant that promote the established direction of advanced art. Steinberg argued that a more

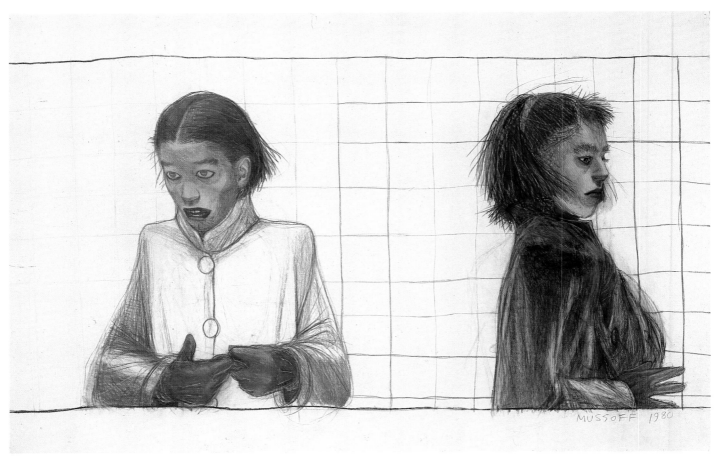

57　Mussoff, *Two Women and Tiling,* 1980

rewarding approach would be one in which the critic held his criteria and taste in reserve and then based his evaluation of a work upon the collective judgment of a generation, one within which many critical insights would be absorbed.[23] Steinberg's view of a constructive process would be one way of opening ourselves to a language and structure dealing with notions of synthesis and pluralism. He has even advanced a suitable time lapse, which is where we are now. Still our current art journals are replete with reports, but critical opinion has neither flourished nor kept up with the revival of representation or the burgeoning pluralism of the 1970s.

Soundly reasoned and sophisticated, Greenberg's formalist criticism, which illuminated and perhaps even directed historical modernism for a time, seems dated and off the mark rather than enlightening or provocative today. A critical vocabulary shaped to deal with a century of abstract, formalist art,

it proves, understandably, to be inadequate when it focuses on the abstract or formalist qualities discerned in the new representation and does not move on to synthesis. Nearly thirty years ago, in 1954, Greenberg wrote, "Actually my own hope is that a less qualified acceptance of the importance of sheerly abstract or formal factors in pictorial art will open the way to a clearer understanding of the value of illustration as such — a value which I, too, am convinced is indisputable. Only it is not a value that is realized by, or as, *accretion.*"[24]

The tension between representation and abstraction, which still seems so implicit in the range of contemporary exhibitions these days, does not necessarily imply a break in historical continuity. Rifts in art, real disagreements, and synthesizing, stormy moments occur throughout history. The changes that are occurring today are cumulative rather than arbitrary. In each period, certain artists

find an integrated visual energy and truth that works for him in the time he lives. This might involve radical innovation or an energetic re-invention and synthesis of historical strains and traditions. Either can be disquieting to the contemporary eye. Unexpected or unlikely encounters often provide new insights, and it is equally important for critics and viewers to detect visual impulse, origin and purpose, foregoing a preference for a static pantheon of modern styles. If we are patient, continuity in art has a way of becoming apparent.

Meanwhile we have artists who are dissatisfied with the criticism of their time and understandably so. If criticism doesn't exist for artists of this particular persuasion in their time, then perhaps they need to invent their own as Fairfield Porter did in his lifetime. Artist and writer Rackstraw Downes and spokesman Philip Pearlstein are no mean contenders. They have developed a critical point of view about

representation and are writing it down.

It is difficult to bring vitality to the commonplace. Representational artists cannot graft the concerns of the present on the forms of the past, and so it becomes necessary to re-invent in order to accomplish an accurate economical reporting of vision and feeling that will include both history and the attributes of the contemporary world. Time and space are handled differently from artist to artist as they grapple with these difficulties.

The element of timelessness in a drawing can be located to the degree that historical consciousness is communicated. The temporal element is expressed by observed personal or worldly attributes found in today's workaday culture. An accretion of time may be expressed in relatively concrete ways by means of the interaction between figures (Jody Mussoff); by mythic references (David Ligare); by suggesting the mutability of the landscape (Rackstraw Downes); or through sparking the viewer by mixing memory with the thing seen (Robert Cottingham). References to the future are being expressed in much recent figurative art as well, with its strong bent toward the subject of uncertainty and survival. Artists have the freedom to use time in many different ways: it can be expanded, abbreviated, contracted, condensed, layered. In a portrait, the sitter's stare or glance can make all the difference. A hard stare will suggest the timelessness of meditation and reflection whether in a Rembrandt portrait or one by Alfred Leslie. A quick, candid glance such as we find in portraits by Hals is also to be found in the representations of D.J. Hall. There is also the variability of focus that the temporal treatment of time can indicate as in the preoccupied and distant glance of William Bailey's *Untitled* (cat. no. 6).

In contrast to minimalist and conceptual work of the 1960s, these drawings are based on what is seen as well as what is known. Illusionism may be reinstated in a synthetic method such as this. However, it no longer equates with representation but carries a secondary role. The fact that some artists' imagery appears to occupy open space in a pre-modernist manner is not the crux of the return to figuration. Rather it is the impact of modernism, beginning with synthetic cubism, that makes its mark here in an emphatic way. In many of these drawings, the viewer will find space rendered as a continuum, according to Greenberg's much-quoted phrase, in which objects inflect but do not interrupt. In such drawings, lines and shapes, which are necessary expressions of each other, make, without losing any of their individuality, an integral space on a two-dimensional plane. Space connects rather than separates. In drawings by Longo and some by Rubin, for instance, figures and objects occupy either non-space or blank space, which increases their sense of isolation.

Each of these artists is a gifted draftsman in his or her way, making us see as he or she saw. They may plan their drawings in every detail and in ways that occur to no one else, or they may work spontaneously without knowing beforehand what will happen. They may mix memory with the thing seen and plain statement with enigma so that the viewer ends up not knowing with any certainty which is which. They are as sensitive to individual destinies as to the state of the nation or the world's turmoil. They make truthful images about people in the passage of time, either looking inward at themselves or looking beyond themselves to their public milieu. Nor do their works require explanations about our world being in this part or that part of a drawing, for the coherent energy that animates their drawings carries with it accuracy, subject matter and emotions that can be communicated. When there is ambiguity, it is the ambiguity of alternatives.

The images depicted here are vulnerable and exposed, yet once again there is resiliency and dignity revealed in human observation. Their drawings connect to and resonate the life of our times.

NOTES

1. See T.S. Eliot, "Tradition and the Individual Talent," *The Sacred Wood: Essays on Poetry and Criticism.* London: Methuen, 1948, pp. 37-44.

2. For a more complete discussion, see Hayden White, "The Culture of Criticism," *Liberations,* ed. Ihab Hassan. Middletown, Conn.: Wesleyan University Press, 1971, pp. 55-69.

3. Detailed with wit in Linda Nochlin, "The Realist Criminal and the Abstract Law," Parts I and II, *Art in America,* vol. 61, September/October 1973, pp. 54-61, and November/December 1973, pp. 97-103.

4. See Linda Nochlin's *Realism and Tradition in Art, 1848-1900.* Englewood Cliffs, N.J.: Prentice-Hall, 1966.

5. The argument is well developed in Douglas Crimp, *Pictures* (exh. cat.). New York: Artists Space, 1979.

6. For a study of the historical background on the concern for the popular and a taste for imagery from modern mass media, see Beatrice Farwell, *The Cult of Images, Baudelaire and the 19th-Century Media Explosion* (exh. cat.). Santa Barbara: UCSB Art Museum, 1977. Farwell's catalogue on the last century's use of mass media presents with clarity the insistence (of Flaubert, Baudelaire and Zola; Courbet, Manet and Degas as well as the Impressionists) that contemporary life is the proper subject for the artist; that the artist can put his finger directly on the pulse of his age by looking to commercial mass media as a source for imagery; and that twentieth-century art is heir to the altered subject matter introduced by artists who rose to the challenge in the middle of the nineteenth century. Farwell makes the point that popularity in word and image was subversive of the old order,

and that it was only in the hands of a generation of high artists that the long-range subversion became apparent, permanently altering art and literature. She further points out that much of the subject matter in popular commercial imagery was derived from urban realities of common visual experience.

For example, Manet's mature works did not develop from illustrative accuracy. Manet painted on the surface, for the most part, and twentieth-century formalists argue that he set the stage for later abstraction purely concerned with art for art's sake. Although Manet incorporated the figurative in his work, the viewer can infer that his mature works were conceived with a flat support organization of horizontals, verticals and obliques and with social commentary. By extension, this is what made Manet contemporary in his time. A related process is going on today among artists who, as members of the first television generation, are using TV, movie stills, photography and performance imagery as source material for their drawings.

7. For a discussion of this idea in another context, see Phyllis Plous, *Contemporary Drawing/New York* (exh. cat.). Santa Barbara: UCSB Art Museum, 1978.

8. Conversations with the artist, October 1982.

9. Conversation with the artist, April 1982.

10. See the letter by R.B. Kitaj, "Painters' Reply," *Artforum,* vol. 14, September 1975, p. 28.

11. For more information, read Robert Rosenblum, "Notes on Alfred Leslie," *Alfred Leslie* (exh. cat.). Boston: Museum of Fine Arts, 1976.

12. Conversation with the artist, May 1982.

13. Conversations with the artist, October 1982.

14. Conversation with the artist, May 1982.

15. Conversations with the artist, March 1982 and September 1982.

16. Conversations with the artist, April 1982 and August 1982.

17. Conversations with the artist, March 1982 and November 1982.

18. Conversation with the artist, May 1982.

19. Conversation with the artist, September 1982.

20. Conversations with the artist, March 1982 and September 1982.

21. See Jeanne Siegel, "Lois Lane and Robert Longo: Interpretation of Image," *Arts Magazine,* vol. 55, November 1980, pp. 156-157.

22. Paraphrase of a statement by Clement Greenberg, "Modernist Painting," *The New Art,* ed. Gregory Battcock. New York: E.P. Dutton, 1966, p. 101.

23. Consult Leo Steinberg, "Other Criteria," *Other Criteria.* New York: Oxford University Press, 1972, pp. 55-92.

24. Clement Greenberg, "Abstract, Representational, and so forth," *Art and Culture.* Boston: Beacon Press, 1961, p. 138. Here Greenberg appears to invite further investigation of the value of illustration and its redefinition.

The Resurgence of Realist Draftsmanship

Eileen Guggenheim

The notion of eloquent *contemporary* draftsmanship can be surprising, for when we think of the term "draftsmanship" it typically evokes either visions of brilliantly fluent old master drawings or of rigorously disciplined nineteenth-century academic studies. Our own century has been guided by abstraction, a force that has altered the traditional relationship between drawing and the other arts. Until the end of the nineteenth century, drawing was regarded as the basic skill to be mastered by any artist, a skill crucial to the successful creation of any painting or sculpture; in the twentieth century this relationship has changed. Perhaps because abstract art has emphasized conceptualism rather than the world of concrete reality, many modern artists have painted or sculpted without recourse to drawing. Others have merged the drawing and painting processes into one — Jackson Pollock and Willem de Kooning, for example. Consequently, the art of drawing in our time has, until very recently, been denied the emphasis placed on it in earlier centuries.

Yet in the past decade, the twentieth century's comparative neglect of the drawing medium has given way to a new flurry of activity. Artists have begun to rediscover drawing's virtues of immediacy and directness and to use the medium's autonomy to create works of art independent of painting. Nevertheless, most recent drawing that has succeeded in winning attention has been abstract in nature. In the catalogue for the exhibition, *Drawings: The Pluralist Decade,* which represented the United States at the 1980 Venice Biennale, organizer Janet Kardon failed to include any realist artists as she and her colleagues surveyed drawing in the 1970s. Kardon's viewpoint, which is typical of progressive taste, dismisses representational drawing as academic or retardataire. Despite the vanguard's ostracism, however, there has been a remarkable resurgence of draftsmanship that can be described as realist or representational. In order fully to appreciate this phenomenon, it is necessary to consider briefly the strength of the modernist tradition, since it provides the background for the current emergence of realism.

The sheer brilliance, inventiveness and raw vigor of much post-World War II American abstract painting

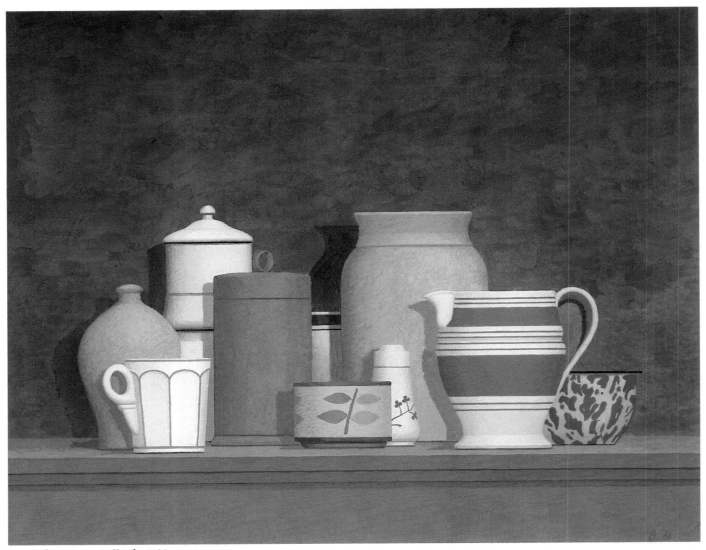

7 Bailey, *Tuoro Still Life,* 1980

effectively eclipsed every other tendency for more than two decades. An eloquent critical establishment helped sustain abstraction's meteoric rise to attention. Clement Greenberg, in particular, had a profound effect on both painters and the art audience and established a doctrinal atmosphere in favor of abstraction that lasted from the 1950s until the mid-1970s. According to Greenberg, modern painting since Manet and Cézanne had been on a reductive course, progressively purging itself of all pictorial elements not intrinsic to the medium. This process, he proclaimed, should continue. Flatness, color, and the shape of the support were held to be essential, while other elements — those mainstays of realist art: illusionism, and readily perceivable iconography, for example — were felt to detract from the more formal investigations of modern painting. Thus, in an art world dominated by the puristic and orthodox requirements of modernist painting, realists became outsiders or even outcasts, for they dared to involve themselves in the taboo of literal content. Linda Nochlin pinpointed the stark polarity that had arisen between the two tendencies by the early 1970s, humorously entitling an article "The Realist Criminal and the Abstract Law."[1]

Modernism's stranglehold, however, depended largely on the staying power of Greenberg's theory and, as time passed, it became increasingly evident that not only was his reductive thinking encouraging the production of images that were increasingly stark and ever more inaccessible, but also that abstraction's claim to exclusivity could not be sustained. In the 1970s anti-modernist trends accumulated, including New Image, New Figuration, and Neo-Expressionism. Many displayed an intensity and an intelligent, contemporary quality that made them impossible to disregard. The rise of these so-called post-modern currents has caused a re-evaluation of abstraction's position in the history of art. Modernism, long claimed by its proponents to be the culmination of Western art, now appears instead to have been but a chapter or episode in its evolution.

During the reign of abstract art, representational painting and drawing

continued, although ignored by many published theorists and exhibited artists. The dazzling rhetoric of modernism overwhelmed other theorists, non-conformists, and the public. Few champions arose to defend realism in the post-war years, and the articulation of a critical theory of realism is only now beginning. Moreover, progressive art schools across the country from the 1950s through the 1970s emphasized the spontaneous, immediate, and gestural modes of creation inspired by Abstract Expressionism and dropped traditional life drawing and foundation courses. Typically, traditional teachers of the pre-war generation who were also draftsmen adapted to modernist methods, thereby permitting their drawing skills to lapse. Indeed, because drawing is a skill that must be continually practiced in order to be maintained, the craft of depictional drawing seemed threatened with extinction until a decade ago.

How, then, did representational painting and sculpture emerge from the modernist bind? What precedents for their resurgence lie in American painting? To put it in the broadest possible terms, the entire history of American art might be cited as one uninterrupted precedent for realism's survival. Several writers, including John McCoubrey in *American Tradition in Painting* and Barbara Novak in *American Painting of the Nineteenth Century,* for example, have maintained that realism has been the most vital and constant American tradition from the colonial portraits of John Singleton Copley to the present day. According to these authors, typical American traits — including hard-headedness, a legendary practicality, and a materialistic bias — have merged to create a uniquely American art in which emphasis is placed on facts — on measurable certainties and the

"thingness and thereness" of the objects depicted.[2] In fact, as recently as our grandparental generation, the majority of American artists were realists. Native representational modes peaked in popularity in the 1930s, with Regionalist painters such as Grant Wood, John Steuart Curry, and Thomas Hart Benton, Social Realists Philip Evergood and Ben Shahn, and Surrealists like Peter Blume. In the same decade, American Precisionist painting, inspired by European Cubism, photography, and the vigor of American industrial structures and architecture, came to maturity. The Precisionists portrayed their technological subject matter in stark, hygienic terms. Indeed, striking similarities exist between the drawings of the Precisionists Charles Demuth and Charles Sheeler and some of the artists of the current generation. For example, Sheeler's *Feline Felicity* of 1934, a charcoal drawing of a cat curled up asleep on a Shaker chair, drawn from a photographic source, has the perfection of perspective, the meticulousness, the rigorously disciplined pencil strokes, and the exacting gradations of value that recur in drawings by James Valerio. And Charles Demuth's delicate wash drawings, such as *Trees,* set objects off dramatically against a blank paper background, emphasizing the abstract quality of the forms in a manner that anticipates Sandra Mendelsohn Rubin's watercolors of still-life objects, rendered with fierce precision on blank, undefined grounds.

Representational painting dominated American art until the years immediately preceding World War II, only to be eclipsed by the great wave of abstraction that swept the art world in the late 1940s. Nevertheless, during the heyday of Abstract Expressionism, representationalism persisted even within its ranks. Encouraged by Willem de Kooning's figurative inclinations, several artists, including Nell Blaine

and Jane Freilicher, developed styles that, though they reverberated with energetic gesturalism, were nevertheless depictional. Fairfield Porter, a gifted realist painter, was also of this generation; he became a protagonist of realism, by then much maligned, and predicted its revival. Certain artists represented in this current exhibition, including Alfred Leslie and William Bailey, who trained as painters in the 1950s, began their careers as abstract artists but later turned to realism.

While figurative art survived in the hands of second-generation Abstract Expressionist landscape and figure painters, a move toward the introduction of a more tightly painted, recognizable imagery began with Larry Rivers' *Washington Crossing The Delaware* (1953). Rivers' painting of a clichéd American image reawakened interest in the banal as subject matter. His broadly brushed and aggressively built-up paint surface maintained links to the rampant gesturalism of Abstract Expressionism, while his mundane, highly literal imagery heralded new possibilities in terms of broadened iconography that ultimately erupted in the form of Pop Art.

From about 1960 Pop Art became the single most important force in restoring recognizable imagery to painting. Pop Art's realism, however, was of a highly abstract and schematic kind, as demonstrated, for example, by Andy Warhol's flat and heraldic *Campbell's Soup Can* (1962). Moreover, irony and jokiness pervaded Pop imagery, disarming any claims to serious purpose on its part. Thus, while Pop seemed radical to modernists because of its materialistic imagery, it assimilated some of abstract art's simplification. At the same time, it posed no serious challenge to modernism's dominance because of its unserious nature.

In the early 1970s a new movement, Photo-Realism, burst on the scene, superseding Pop in media attention and popular appeal. Based on photographic source material, Photo-Realism was initially perceived as a kind of stepchild of Pop for, like its predecessor, it appeared to thrive on clichéd, banal images of American life. Certainly, early Photo-Realists like Malcolm Morley and John Clem Clarke, conditioned by Pop's tendency toward ironical social commentary, recreated pre-existing source material with sociological intent. Morley's principal source was the travel brochure, while Clem Clarke was drawn to Old Master reproductions. However, as the Photo-Realists developed individual styles, an unusual twist occurred. Artists such as Richard Estes, Robert Bechtle, Chuck Close, and Audrey Flack became increasingly absorbed in the richness of the information their photographic source material revealed. Any echo of Pop's fanatical social commentary dissipated as these Photo-Realists slowly and painstakingly transformed that information by means of paint on canvas to produce complicated, realistic images that advanced representationalism far beyond the point where Pop had left it.

The high degree of illusionism present in Photo-Realist canvases caused most vanguard critics to shun the movement. However a few, more receptive, detected in Photo-Realism a degree of modernist simplification that stemmed from its two-dimensional source material. Photo-Realism's residual flatness was, in fact, the key to its ultimate importance, for it permitted the movement to coexist comfortably within two different camps: on the one hand, it seemed respectfully to acknowledge modernism's own commitment to flatness, while on the other it re-introduced the more traditional

concerns of realism. Photo-Realism is manifestly a serious movement that has driven a wedge into the exclusive domain of modernism and opened up a host of possibilities for serious artists interested in developing the representational enterprise in contemporary terms.

If Photo-Realism demonstrated that realism could once again be a legitimate concern for modern artists, public institutions and art journals have, in recent years, reinforced the possibility by bringing descriptive art, both historical and contemporary, into the public eye. In 1967, the historical tradition was the subject of a major exhibition, *The Triumph of Realism: An Exhibition of European and American Realist Painting, 1850-1910,* at the Brooklyn Museum. American museums have, since then, regarded this topic in many other exhibitions — too numerous to list exhaustively, but including the following important surveys: *Reality of Appearance: The Tromp l'Oeil Tradition in American Painting,* the National Gallery of Art, 1970; *American Light: The Luminist Movement, 1850-1875,* the National Gallery of Art, 1980; and *The Realist Tradition: French Painting and Drawing, 1830-1910,* the Cleveland Museum of Art, 1980. Individual artists have also been the subject of major exhibitions, including large-scale surveys of work by Sir Edwin Landseer, a Victorian genre painter and Thomas Eakins, both recently shown at the Philadelphia Museum. Traditional realist art is now avidly collected; the National Gallery of Art and the Los Angeles County Museum recently exhibited the Ganz collection, an important private collection of nineteenth-century American academic art.

Contemporary realism has also been the subject of several recent and important exhibitions, such as *Real,*

Really Real, Super Real, organized by the San Antonio Museum of Art; *Contemporary American Realism since 1960,* by the Pennsylvania Academy of Art; and *Seven Photo-Realists,* held at the Guggenheim Museum, long a bastion of non-objective art.

In addition to group painting exhibitions, a number of individual retrospectives have been held featuring, among others, the work of Richard Estes, Gregory Gillespie, Alfred Leslie, and David Hockney. Commercial gallery support of contemporary representational art is now stronger than ever. In New York the Frumkin and Schoelkopf galleries have long been supporters of living realists, while the O.K. Harris and Louis K. Meisel galleries have both specialized in Photo-Realist painting. Realism has also captured the attention of major art magazines. *Art in America,* for example, devoted a special issue to the phenomenon in September 1981.

Although realist painting has acquired a new prestige and visibility and has won a conspicuous place in the contemporary art world, little attention has been paid to descriptive drawing. At least one major survey of drawing in the past decade essentially excluded representational drawing in favor of a focus on abstraction. To date, only two major museum exhibitions of drawings have included a significant body of realist work. *American Drawings in Black and White: 1970-1980,* held at the Brooklyn Museum, included a number of realists within a survey of the drawing medium that dealt largely with abstract artists. Only one recent museum exhibition has been exclusively devoted to representational drawing, *Perspectives on Contemporary Realism: Drawings from the Davidson Collection,* organized by Frank Goodyear, Jr., for the Pennsylvania Academy of Fine Arts. A reflection of two collectors' taste, that exhibition

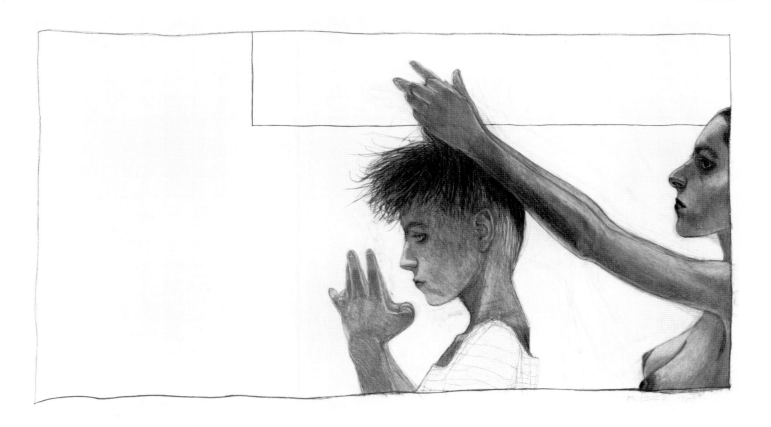

59　Mussoff, *Woman Fixing Girl's Hair,* 1980

cannot be considered comprehensive.

Several facts help to explain the general neglect of contemporary representational drawing. Among them are the twentieth-century tendency to view drawing as a minor or auxiliary art, and residual modernist biases on the part of critics, museum curators, and collectors. Such people often dismiss realist drawing, considering it a retrograde reflection of the academic tradition of draftsmanship. They fail to recognize that while many contemporary realists are in fact interested in the classical tradition of drawing, these artists are nevertheless aware of intervening visual and conceptual modes and have imbued their work with a modernity that makes it unmistakably of our time. Finally, it is important to note that the battle for recognition that realism has waged over the past decade has largely been through the medium of painting rather than drawing. This is quite natural, for traditionally painting has been the more ambitious, elaborate, and visible

art of the two, and it is from painting that critical theory is generated.

Given the recent history of art and the lack of adequate training methodologies in traditional draftsmanship, it is remarkable how many exceptional descriptive draftsmen have succeeded in emerging. Moreover, members of the current generation have no inhibitions about being realists. They are not aimlessly searching for a style or method of working, but rather have found something interesting — they enjoy drawing recognizable imagery. They have come to grips with representation and are moving confidently in new and varied directions. Indeed, fundamental to both realist painting and drawing today is the understanding that this direction is not a cohesive, exclusive, or doctrinaire movement, but rather a heterogeneous one that takes a variety of different paths. It is also important to emphasize that the current crop of representational draftsmen is by no means uniformly anti-modern. David

Hockney, for example, has been fascinated with Cubism throughout his career, and its influence continually surfaces in his art. William Bailey's *Tuoro Still Life* (cat. no. 7), a spartan grouping of humble crockery painstakingly arranged and set off against a stark, undefined background, is as ascetic in its sensibility as any work of Minimalist painting of the 1960s and 1970s. John Nava's *No. 5* (cat. no. 63) inhabits an electric blue, radically flattened ground that enables the drawing to be read either for its literal content (the model and the mirror image) or as an abstract interplay of colors and flat forms. Vija Celmins invariably views her environmental subject matter, such as waves and lunar surfaces, in extreme close-up; repetitive in nature, her themes expand into all-over compositions that also lend themselves to abstract readings.

The work of some draftsmen considered here relates to modernism's qualities of flatness and its preference for abstract forms; others among them

have turned away from abstract sensibilities and have consciously attempted to return to premodern prototypes. Finely observed detail in Martha Mayer Erlebacher's *Alexis* (cat. no. 26), Gregory Gillespie's *Self-Portrait* (cat. no. 29), and Sandra Mendelsohn Rubin's *Self-Portrait* (cat. no. 67) betrays an intensity that stems from an interest in Albrecht Dürer and pre-Renaissance art. Alfred Leslie has spoken repeatedly of his wish to return to the monumental expression of the premodern masters. Echoing Leslie's yearning for the heroic in art, David Ligare, a specialist in allegorical scenes who is particularly interested in themes from classical antiquity, has written of his own work: "It seems that the time is right for something truly heroic and uncompromisingly beautiful. Whether contemporary art can contribute to that remains to be seen, but why not?"[3]

The single most pervasive influence on current representational drawing is the camera. Whether or not these artists use photographic source material as an adjunct to their drawing, they share a general familiarity with photographic vision that often results in a marked tendency toward highly elaborate subject matter and an extremely meticulous and tight rendering style. Robert Cottingham's *Ritz Hotel* (cat. no. 16), for example, contains numerous shop signs, logos, a decorative awning and a marquee arranged against the contrasting textures of a varied group of architectural façades. The human eye alone could not possibly assimilate the infinite details of this elaborate conglomeration of forms and textures with such clarity. In *Condessa del Mar* (cat no. 30), D.J. Hall captures the raw spontaneity of a snapshot, but then goes beyond photographic fact in its deliberately hard pencil marks and electrifying, acid palette.

The heightened sense of presence

and the through-the-looking-glass quality of much of the rendering in the current exhibition demonstrate the intensity inherent in the drawings, and it is this intensity that manifests the work's contemporary quality. These are artists who are deeply engaged in realist imagery, and whose depth of observation and ability to concentrate yield remarkably complicated images. They go about their work with a serious dedication that is far removed from the trendiness of so many of art's current directions. While their drawing may build on a framework of old values and traditions, it nevertheless expresses a thoroughly new sensibility. These artists have achieved remarkable technical ability and have produced work of high quality. They have created images that through their detail and psychological potency both challenge and stimulate the viewer.

This exhibition, then, examines artists who, despite differences in subject matter, style, and temperament, are united by an ability to excel in the drawing medium. They are, one and all, natural and confident draftsmen. They do not look over their shoulders at what the long-accepted abstract artists are doing, nor is their work in any way tentative or experimental. Displaying the painstaking skill that the drawing medium requires, they take pleasure in the slow accretion of carefully executed marks and produce refined and self-assured works. Their aim is to prove that, in merging highly skilled rendering techniques with a commitment to the visible world, their work represents a vital alternative for artists today.

NOTES

1. See Linda Nochlin, "The Realist Criminal and the Abstract Law," Parts I and II, *Art in America,* vol. 61, September/October 1973, pp. 54-61, and November/December 1973, pp. 97-103.

2. See John McCoubrey, *American Tradition in Painting,* New York: George Braziller, 1970, and Barbara Novak, *American Painting of the Nineteenth Century,* New York: Praeger Publications, 1969, for a more complete discussion of the unique characteristics of American art.

3. Letter from the artist, 10 September 1982.

Catalogue of the Exhibition

All dimensions are in inches,
height preceding width

AKIRA ARITA

1 *Still Life with Architectural
Fragments* 1982
pencil on paper
24 1/8 x 33 7/16
signature and date lower center
Courtesy Staempfli Gallery, New York

2 *Box and Line* 1982
mixed media
23 x 27 1/2
Signature and date lower center
Courtesy Staempfli Gallery, New York

3 *Vertical Still Life II* 1982
charcoal on paper
48 x 60
signature and date lower center
Courtesy Staempfli Gallery, New York

WILLIAM BAILEY

4 *Untitled* 1976
pencil on paper
14 x 11
signature and date lower left
Collection Mrs. Gretchen Weiss

5 *Still Life with Eggs* 1978
pencil on paper
11 x 15
signature and date lower right
Collection Mrs. Robert Schoelkopf

6 *Untitled* 1980
pencil on paper
30 x 22
Collection Montclair Art Museum
Eleanor Dickson Seidler Redfield
Fund

7 *Tuoro Still Life* 1981
casein on paper
16 x 20
signature and date lower right
Collection Barney A. Ebsworth

WILLIAM BECKMAN

8 *Study for John Deckert* 1980
charcoal on paper
70 x 48
signature and date lower right
Lent by artist
Courtesy Allan Frumkin Gallery,
New York

9 *Power Lines* 1982
pastel on paper
24 x 32 1/2
signature and date lower left
Courtesy Allan Frumkin Gallery,
New York

10 *Study for Power Lines* 1982
pencil on paper
20 x 25
signed lower right: WB
Courtesy Allan Frumkin Gallery,
New York

11 *Study for Baldwin Farms* 1982
pencil on paper
23 1/2 x 29
signature and date, lower left
Courtesy Allan Frumkin Gallery,
New York

VIJA CELMINS

12 *Galaxy (Cassiopeia)* 1973
graphite on acrylic ground on paper
12 x 14 1/2
signature on reverse
Collection Donald B. Marron

13 *Galaxy (Hydra)* 1974
graphite on acrylic ground on paper
12 x 15
signature on reverse
Collection Edward and Melinda
Wortz

14 *Untitled (Ocean)* 1977
graphite on acrylic ground on paper
12 x 15
signature on reverse
Collection Alfred M. Esberg

15 *Untitled (Snow Surface)* 1977
graphite on acrylic ground on paper
12 x 15
signature and date on reverse
Collection of the artist

ROBERT COTTINGHAM

16 *Ritz Hotel* 1982
graphite on vellum
13 x 20
signature and date lower right
Courtesy Coe Kerr Contemporary,
New York

17 *J. C.* 1982
graphite on vellum
13 x 20
signature and date lower right
Courtesy Coe Kerr Contemporary,
New York

18 *Hall's Diner* 1982
watercolor on paper
13 x 20
signature and date lower right
Courtesy Coe Kerr Contemporary,
New York

19 *The Spot* 1982
watercolor on paper
21 x 28
signature and date lower right
Private Collection

RACKSTRAW DOWNES

20 *Sprowl's Lumber Yard* 1976
pencil on paper
11 1/2 x 41 1/2
signed lower right: RD
Collection Mr. and Mrs. Peter R. Blum

21 *Looking up 107th* 1978
pencil on paper
23 1/4 x 32 3/4
signed lower right: RD
Collection Mr. and Mrs. Peter R. Blum

22 *Riverside Drive with Gates of
Columbia* 1979
pencil on paper
18 x 32
signed lower right: RD
Collection Mr. and Mrs. Peter R. Blum

23 *The View South from Washington
Bridge on the Harlem River* 1982
pencil on paper
19 x 35 14
signed lower right: RD
Collection Mr. and Mrs. Peter R. Blum

MARTHA MAYER ERLEBACHER

24 *Still Life for Embrace* 1973
watercolor on paper
21 x 27
signature lower left, date lower right
Courtesy Robert Schoelkopf Gallery,
Ltd., New York

23 *Face* 1975
pencil on paper
13 1/2 x 11
signature lower left, date lower right
Collection Stuart Handler Family

26 *Alexis* 1979
pencil on paper
13 1/2 x 11
signature and date lower right
Collection Margot Gordon

27 *Still Life Supreme* 1979
watercolor on paper
13 3/4 x 20
signature lower right, date lower left
Collection Mrs. William Janss

GREGORY GILLESPIE

28 *Self-Portrait* 1979
charcoal on paper
23 x 16 1/2
signature and date lower right
Courtesy Forum Gallery, New York

29 *Self-Portrait* 1979
oil wash on paper
24 x 20
signature and date lower right
Courtesy Forum Gallery, New York

D. J. HALL

30 *Condessa del Mar* 1979
color pencil on paper
22 1/2 x 29
signature and date lower right
Courtesy Hold'em Art Association,
New York

31 *Jan and Bubbles* 1982
color pencil on paper
12 3/4 x 17 3/4
signature and date lower right
Collection Mr. and Mrs. Richard
Manney

32 *Too Pretty to Worry* 1982
color pencil on paper
22 1/2 x 29
signature and date lower right
Courtesy O.K. Harris Works of Art,
New York

DAVID HOCKNEY

33 *Fire Island Pines* 1975
color pencil on paper
17 x 14
signature and date lower right
Lent by Harry and Linda Macklowe

34 *Study of Water, Phoenix,
Arizona, No. 4* 1976
color pencil on paper
15 3/4 x 17 3/4
signature and date lower left
Private Collection

35 *Hotel Room, Hot Springs,
Arkansas* 1976
color pencil on paper
14 x 16 7/8
signature and date lower right
Private Collection
(not in tour)

36 *Maurice Sleeping* 1977
pen and ink on paper
14 x 17
signature lower right, date on reverse
Collection Mr. and Mrs. Walter Nathan

37 *Sir John Gielgud* 1977
ink on paper
17 x 14
signature with inscription lower right
Collection The Fine Arts Museums
of San Francisco, Achenbach
Foundation for Graphic Arts

38 *Marinka* 1978
color pencil on paper
23 3/4 x 20 1/4
signature and date lower right
Collection Mr. and Mrs. Steve
Schapiro

R. B. KITAJ

39 *The Sneeze* 1975
pastel, charcoal and pencil on paper
34 x 27
signature, inscription and date
lower right
Collection The Museum of Modern
Art, New York
Gift of Nancy and Jim Dine

40 *The Symbolist* 1978
pastel and oil crayon on paper
39 3/8 x 25 1/2
signature lower right
Collection Mr. and Mrs. Edward L.
Gardner

41 *Sixth Avenue Madman* 1979
pastel and charcoal on paper
30 1/2 x 11
signature lower right
Collection Dr. Jack E. Chachkes

ALFRED LESLIE

42 *Seated Model* 1977
pencil on paper
40 x 30
signature and date lower center
Courtesy Allan Frumkin Gallery,
New York

43 *Self-Portrait of the Artist in
his Studio* 1979
pencil on paper
80 x 60
signature and date lower left
Collection Dr. Gerard L. Seltzer

44 *Preparatory Drawing for "In the
Studio of Gretchen McLaine"* 1980
pencil on paper
40 x 30
unsigned
Courtesy Allan Frumkin Gallery,
New York

DAVID LIGARE

45 *Ideal Head* 1980
pencil on paper
23 x 31
signature and date lower right
Lent by artist

46 *Woman in Greek Chair
(Penelope)* 1980
pencil on paper
23 x 31
signature and date lower left
Lent by artist

47 *Et in Arcadia Ego* 1981
pencil on paper
23 x 31
signature and date on reverse
Lent by artist

48 *Young Man with
Photograph* 1982
pencil on paper
31 x 23
signature and date lower left
Lent by artist

ROBERT LONGO

49 *Untitled* 1978
charcoal on paper
30 x 40
signature on reverse
Collection Robert M. Halff

50 *Untitled (Men in the Cities
Series: Eric)* 1981
charcoal and graphite on paper
96 x 60
signature and date on reverse
Collection Scott Spiegel

51 *3 S. S. (For Scott)* 1982
tempera and pencil on paper
22 x 30
signature and date lower right
Collection Scott Spiegel

52 *Study for Final Life Series
(Men in the Cities)* 1982
tempera and pencil on paper
44 x 30 1/8
signature and date lower right
Collection Scott Spiegel

JOHN MANDEL

53 *Man Changing Arc of Thrown
Object* 1980
pencil on paper
40 1/2 x 37
signature and date lower right
Lent by artist
Courtesy Koplin Gallery, Los Angeles

54 *Installation Drawing* 1982
pencil on paper
57 x 54
signature and date lower right
Courtesy Koplin Gallery, Los Angeles
(not in tour)

55 *Untitled* 1982
charcoal and pencil on paper
33 x 32
signature and date lower right
Courtesy Koplin Gallery, Los Angeles

56 *Untitled* 1982
pencil on paper
31 1/2 x 29 1/2
signature and date lower right
Courtesy Koplin Gallery, Los Angeles

JODY MUSSOFF

57 *Two Women and Tiling* 1980
color pencil on paper
25 x 41
signature and date lower right
Courtesy Monique Knowlton Gallery,
New York

58 *Joseph* 1980
color pencil on paper
25 1/2 x 40
signature and date lower right
Courtesy Monique Knowlton Gallery,
New York

59 *Woman Fixing Girl's Hair* 1980
color pencil on paper
40 x 26 1/2
signature and date lower right
Courtesy Monique Knowlton Gallery,
New York

60 *Two Girls Praying* 1981
color pencil on paper
40 x 26 1/2
signature and date on right edge
Courtesy Monique Knowlton Gallery,
New York

JOHN NAVA

61 *No. 4* 1980
pencil, acrylic and oil on paper
40 x 60
signature and date lower center
Collection Daniel Boley

62 *Erin Webster* 1981
pencil and tape on tracing paper
39 1/2 x 27 3/4
signature and date lower center
Lent by artist
Courtesy Koplin Gallery, Los Angeles

63 *No. 5* 1982
pencil, acrylic and oil on paper
28 x 76
signature and date lower center
Collection Mr. and Mrs. David
Hermelin

GREGORY PAQUETTE

64 *Portrait of Phillip Bruno* 1981
charcoal, pencil and conte crayon
on paper
40 x 29
signature and date lower left
Collection Phillip A. Bruno

65 *Flayed Rabbits* 1981
charcoal on paper
30 1/2 x 28 3/4
signature and date lower right
Courtesy Staempfli Gallery, New York

66 *Attic III* 1982
charcoal and pencil on paper
25 1/2 x 39
signature and date lower left
Private Collection
Courtesy Staempfli Gallery, New York

SANDRA MENDELSOHN RUBIN

67 *Self-Portrait* 1981
color pencil on paper
30 x 22
signature and date lower right
Courtesy L.A. Louver Gallery, Venice

68 *Bromeliad* 1981
color pencil on paper
24 x 18
signature and date lower right
Collection of the artist

69 *Chrysanthemum Flower* 1981
crayon and color pencil on paper
30 x 22
signature and date on reverse
Private Collection

70 *Artist with Broken Leg* 1982
watercolor on paper
24 3/8 x 18
signature and date lower right
Courtesy L.A. Louver Gallery, Venice

RONALD SHERR

71 *St. Mark's Church* 1980
graphite and oil wash on paper
22 1/2 x 12 3/4
signature lower right
Collection of the artist

72 *José* 1981
charcoal and gesso on paper
24 5/8 x 19
signature, inscription and date
lower right
Collection José R. Bordes

73 *Betty's Babies* 1981
charcoal and pastel on paper
44 x 30
signature and date lower left
Courtesy Sindin Galleries, New York

WAYNE THIEBAUD

74 *Five Hammers* 1972
pencil, pastel and oil on paper
22 x 30
signature and date lower right
Collection Allan Stone

75 *Street with Shadow* 1982
charcoal on paper
29 x 21
signature and date upper right
Collection of the artist

76 *Rock Ridge* 1982
pastel on paper
32 x 20
signature and date upper right
Collection of the artist

77 *Caged Pie* 1982
pastel on paper
20 x 32
signature and date upper right
Collection of the artist

JAMES VALERIO

78 *Study for Differing Views:
Interior* 1981
sepia on paper
22 3/8 x 27
signature lower right, date on reverse
Collection Jay Y. Roshal

78 *Tightrope Walker* 1981
pencil on paper
29 x 23
signature and date lower right
Collection Dr. Thomas A. Mathews

80 *Paul in a Scary Mask* 1981
pencil on paper
41 1/2 x 29 1/2
signature lower right
Collection Paulette Solow

81 *Reclining Nude, 1982* 1982
pencil on paper
22 1/2 x 30 1/8
signature
Collection Dr. Eugene A. Solow

Artists

Akira Arita

1 Arita, *Still Life with Architectural Fragments*, 1982

2　Arita, *Box and Line,* 1982

Born 1947, Osaka, Japan. Received B.F.A. from Rhode Island School of Design, 1970. Lives in Rhode Island.

Selected Individual Exhibitions

1982 Staempfli Gallery, New York.

Selected Group Exhibitions

1978 *New Acquisitions Exhibition: Prints and Drawings,* The Brooklyn Museum, New York / 1980-1981 *American Drawing in Black and White, 1970-1980,* The Brooklyn Museum, New York (brochure) / 1981 *The Art of Drawing II,* Staempfli Gallery, New York, and Arkansas Art Center, Little Rock / *One Hundred New Acquisitions: Prints, Drawings and Photographs,* The Brooklyn Museum, New York / 1982 *Director's Choice,* Museum of Art, Pennsylvania State University, University Park / *Still Life,* Contemporary Art Center, New Orleans / *Works on Paper,* Weatherspoon Art Gallery, University of North Carolina, Greensboro (catalogue).

Selected Reading

Cohen, Ronny H. "Drawing the Meticulous/Realist Way," *Drawing.* New York: The Drawing Society, vol. 3, March/April 1982, p. 123.

Kramer, Hilton. "American Drawings of the 70's at The Brooklyn Museum," *The New York Times,* 28 November 1980, pp. C1, 18.

————. "A January Guide to Gallery Hopping Uptown," *The New York Times,* 15 January 1982, p. 18.

Wolff, Theodore. "Drawing is Back in Style," *Christian Science Monitor,* 15 June 1981.

5 Bailey, *Still Life with Eggs,* 1978

William Bailey

Born 1930, Council Bluffs, Iowa. Attended
University of Kansas, School of Fine Arts;
received B.F.A. 1955, and M.F.A. 1957, from
Yale School of Art and Architecture.
Lives in Connecticut.

Selected Individual Exhibitions

1956 Robert Hull Fleming Museum,
University of Vermont, Burlington / 1957,
1958, 1961 Kanegis Gallery, Boston /
1963 Indiana University Museum of Art,
Bloomington / 1967 Kansas City Art
Institute, Kansas City / 1968, 1971,
1974 Robert Schoelkopf Gallery, New
York / 1973 Galleria La Parisina, Turin;
Galleria Dei Lanzi, Milan; Galleria il Fante di
Spade, Rome / 1974 The Dart Gallery,
Chicago / 1978 Galerie Claude Bernard,
Paris / 1979 *Recent Paintings,* Robert
Schoelkopf Gallery, New York (catalogue) /
1980 Galleria d'Arte il Gabbiano, Rome /
1982 *Recent Figure and Still Life Paintings,*
Robert Schoelkopf Gallery, New York
(catalogue).

Selected Group Exhibitions

1964 *The Figure, Drawings 1500-1964,*
University of Iowa Art Museum, Iowa City /
1968 *Realism Now,* Vassar College Art
Museum, Poughkeepsie (catalogue) /
1970 *22 Realists,* Whitney Museum of
American Art, New York (catalogue) /
1972 *Five Figurative Artists,* Kansas City Art
Institute / *The Realist Revival,* American
Federation of the Arts (catalogue and
tour) / 1973 *Realism Now,* New York
Cultural Center / *Seven Realists,* Yale
University Art Gallery, New Haven
(catalogue) / 1977 *William Bailey and
Constantino Nivola,* American Academy in
Rome / 1978 *Salon de Mai,* Paris /
1979 *Artists Choose: Figurative/Realist Art,*
Artists' Choice Museum, New York /
1980 *The Figurative Tradition,* Whitney
Museum of American Art, New York /
Realism/Photo-Realism, Philbrook Art
Center, Tulsa (catalogue) / 1981 *Real,
Really Real, Super Real,* San Antonio
Museum of Art (catalogue and tour) /
*Contemporary American Realism since
1960,* Pennsylvania Academy of the Fine
Arts, Philadelphia (catalogue and tour) /
Albers: His Art and Influence, Montclair Art
Museum, Montclair, New Jersey / *The Image
in American Painting and Sculpture
1950-1980,* Akron Art Museum (catalogue)
/ *American Painting: 1930-1980,* Haus der
Kunst, Munich.

Selected Reading

Gruen, John. "William Bailey: Mystery and
Mastery," *ARTnews,* vol. 78, November 1979,
pp. 140-145.

Henry, Gerrit. "A preference for the perfect,"
ARTnews, vol. 78, April 1979, p. 145.

Hollander, John. *William Bailey, Recent
Paintings* (exh. cat.). New York: Robert
Schoelkopf Gallery, 1982.

Kramer, Hilton. "William Bailey and the
Artifice of Realism," *The New York Times,*
26 October 1974, p. 25.

Lanes, Jerrold. "William Bailey," *Artforum,*
vol. 10, January 1972, p. 61.

Strand, Mark. *William Bailey, Recent
Paintings* (exh. cat.). New York: Robert
Schoelkopf Gallery, 1979.

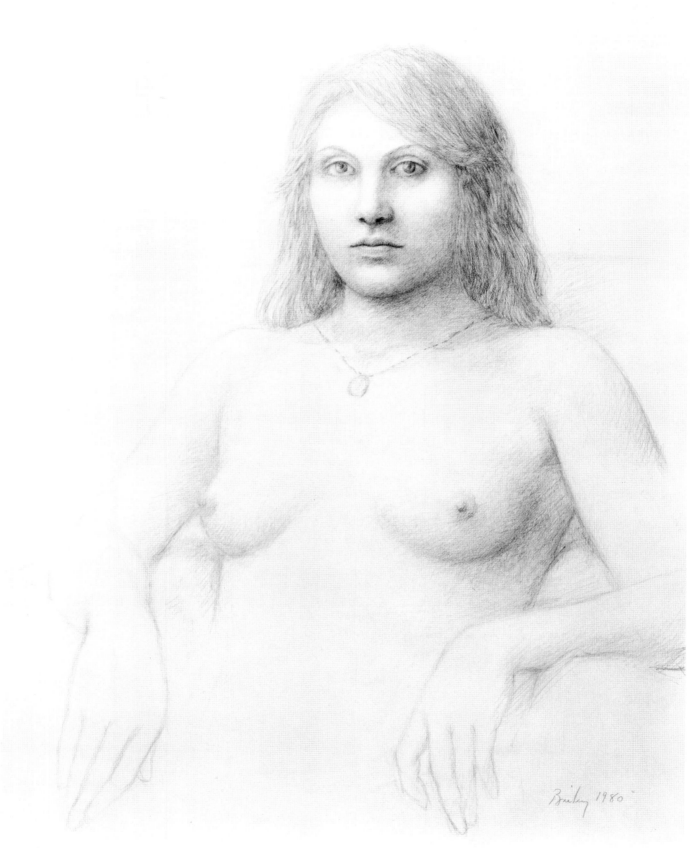

6 Bailey, *Untitled,* 1980

William Beckman

Born 1942, Maynard, Minnesota. Received B.A. from St. Cloud University; M.A. and M.F.A. from University of Iowa. Lives in upstate New York.

Selected Individual Exhibitions

1969 University of Iowa, Iowa City / Hudson River Museum, Yonkers / 1970, 1971, 1974, 1976, 1978, 1980 Allan Stone Gallery, New York / 1982 Allan Frumkin Gallery, New York.

Selected Group Exhibitions

1973 *Realism Now,* New York Cultural Center / *American Drawing, 1970-1973,* Yale University Art Gallery, New Haven / 1974 *Aspects of the Figure,* Cleveland Museum of Art / *Trends in Contemporary Realist Painting,* Museum of Fine Arts, Boston / 1975 *Portrait Painting, 1970-1975,* Allan Frumkin Gallery, New York / 1976 *Modern Portraits: The Self and Others,* Wildenstein Gallery, New York / 1978 *Contemporary Masters,* Allan Stone Gallery, New York / *Painting and Sculpture,* Indianapolis Museum of Art / 1979 *Images of the Self,* Hampshire College, Amherst / *American Portraits of the Sixties and Seventies,* Aspen Center for the Visual Arts / *Seven on the Figure,* Pennsylvania Academy of the Fine Arts, Philadelphia / 1980 *American Portrait Drawings,* National Portrait Gallery, Washington, D.C. / *Realism/Photo-Realism,* Philbrook Art Center, Tulsa (catalogue) / 1981 *Directions 1981,* Hirshhorn Museum and Sculpture Garden, Washington, D.C. (catalogue) / 1981 *Inside Out,* Newport Harbor Art Museum, Newport Beach (catalogue and tour) / *Real, Really Real, Super Real,* San Antonio Museum of Art (catalogue and tour) / *Contemporary American Realism since 1960,* Pennsylvania Academy of the Fine Arts, Philadelphia (catalogue and tour) / *American Painting, 1930-1980,* Haus der Kunst, Munich / 1982 *Focus on the Figure,* Whitney Museum of American Art, New York / *Contemporary Realism,* Brainard Art Gallery, State University of New York, Potsdam (catalogue and tour).

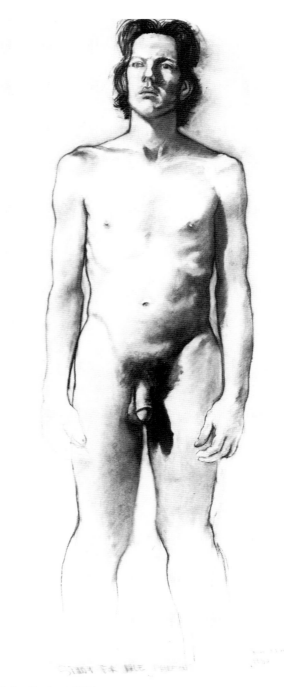

8 Beckman, *John Deckert,* 1980

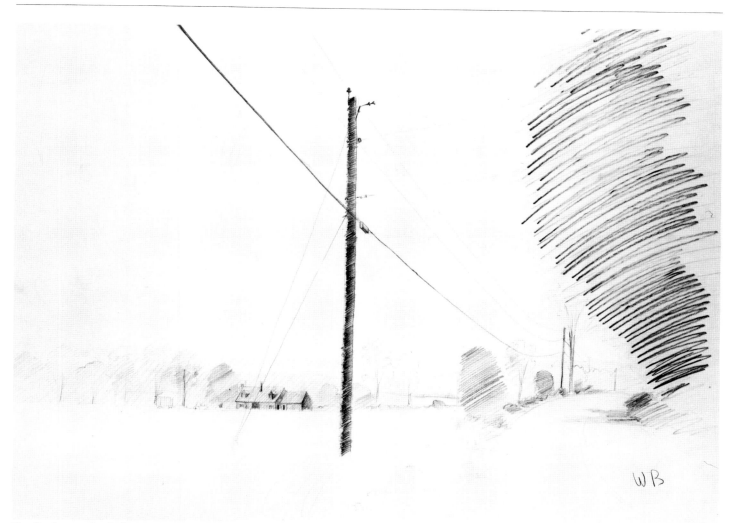

11 Beckman, *Study for Power Lines,* 1982

Selected Reading

Andre, Michael. "William Beckman," *ARTnews,* vol. 73, September 1973, p. 112.

Arthur, John. *William Beckman, Landscape Pastels* (exh. cat.). New York: Allan Frumkin Gallery, 1982.

Deckert, John. "William Beckman," *Arts Magazine,* vol. 54, March 1980, p. 14.

Ellenzweig, Allan. "William Beckman," *Arts Magazine,* vol. 51, April 1979, p. 32.

Martin, J. "Introducing William Beckman," *Newsletter.* New York: Allan Frumkin Gallery, no. 13, Fall 1981, p. 5.

15 Celmins, *Untitled (Snow Surface),* 1977

Born 1939, Riga, Latvia. Received B.F.A. from John Herron Art Institute, 1962; M.F.A. from University of California, Los Angeles, 1965. Lives in California and New York.

Selected Individual Exhibitions
1966 David Stuart Galleries, Los Angeles **/** 1969, 1973 Riko Mizuno Gallery, Los Angeles / Whitney Museum of American Art, New York **/** 1975 Felicity Samuel Gallery, London / Broxton Gallery, Los Angeles **/** 1978 Security Pacific National Bank, Los Angeles **/** 1980 *Vija Celmins, A Survey Exhibition,* Fellows of Contemporary Art and Newport Harbor Art Museum, Newport Beach (catalogue and tour).

Selected Group Exhibitions
1969 *Contemporary American Drawings,* Fort Worth Art Museum **/** 1970 *Annual of Contemporary American Sculpture,* Whitney Museum of American Art, New York (catalogue) **/** 1971 *Continuing Surrealism,* La Jolla Museum of Contemporary Art **/** 1973 *American Drawings,* Whitney Museum of American Art, New York **/** 1975 *A Drawing Show,* Newport Harbor Art Museum, Newport Beach / *Recent Drawings,* Huntsville Museum of Art (catalogue and tour) **/** 1976 *America 1976,* Corcoran Gallery of Art, Washington, D.C. (catalogue and tour) / 1977 *American Artists: A New Decade,* Detroit Institute of Arts (catalogue and tour) / *Painting and Sculpture in California,* San Francisco Museum of Modern Art (catalogue and tour) / *Biennial Exhibition,* Whitney Museum of American Art, New York (catalogue) **/** 1981 *American Realism,* Philadelphia Museum of Art **/** 1982 *Great Big Drawings,* Hayden Gallery, Massachusetts Institute of Technology, Cambridge.

Selected Reading

Armstrong, Richard. "Of Earthly Objects and Stellar Sights: Vija Celmins," *Art in America,* vol. 69, May 1980, pp. 100-107.

Hazlitt, Gordon J. "Vija Celmins: A reductionist by nature," *ARTnews,* vol. 77, February 1978, pp. 66-67.

Knight, Christopher. "Vija Celmins, Newport Harbor Art Museum," *Artforum,* vol. 18, March 1980, p. 80.

Larsen, Susan C. "A Conversation with Vija Celmins," *Journal,* Los Angeles Institute of Contemporary Art, no. 20, October/November 1978, pp. 36-40.

_____. "Vija Celmins," *A Survey Exhibition* (exh. cat.). Los Angeles: Fellows of Contemporary Art, 1980.

Livingston, Jane. "Four Los Angeles Artists," *Art in America,* vol. 58, September/October 1970, pp. 129-130.

Russell, John. "A Remarkable Museum Debut," *The New York Times,* 27 July 1980, Section II, p. 25.

Wilson, William. "Art Walk," *Los Angeles Times,* 25 May 1973, Part IV, p. 8.

_____. "Vija Celmins' Expressions of Anxiety," *Los Angeles Times,* 6 January 1980, Calendar, p. 78.

Wortz, Melinda. "Autobiographical Erasers," *ARTnews,* vol. 79, April 1980, pp. 171-172.

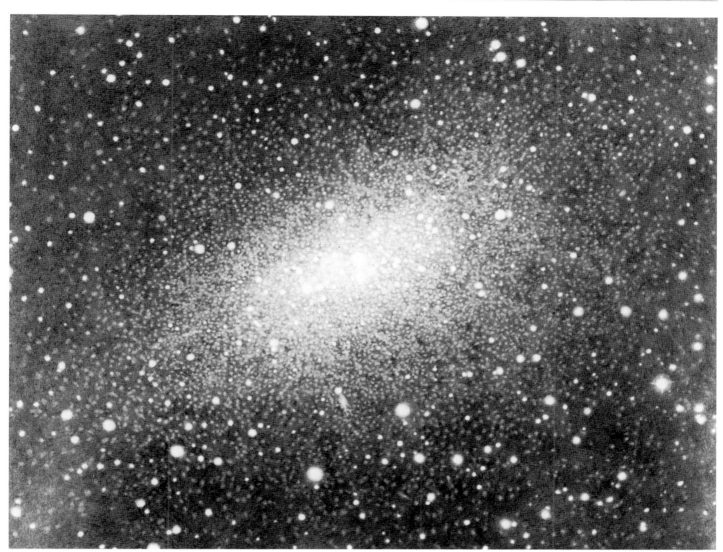

12 Celmins, *Galaxy (Cassiopeia),* 1973

Vija Celmins

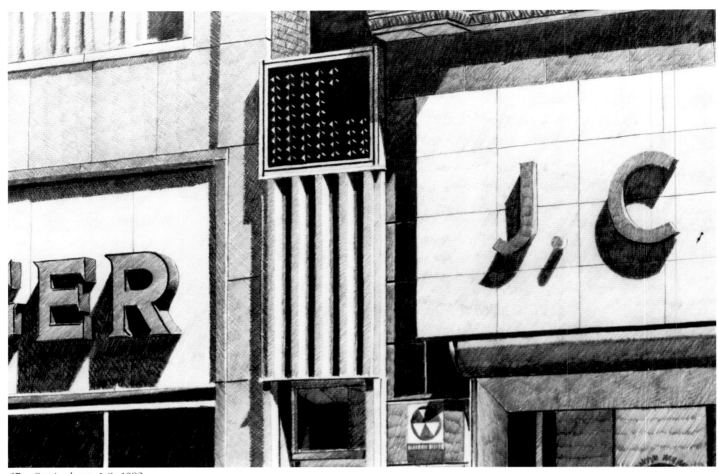

17 Cottingham, *J.C.,* 1982

Robert Cottingham

Born 1935, Brooklyn, New York. Attended
Pratt Institute, 1959-1963. Lives in
Connecticut.

Selected Individual Exhibitions

1968, 1969, 1970 Molly Barnes Gallery,
Los Angeles **/** 1971, 1974, 1976, 1978
O.K. Harris, New York **/** 1975 DM Gallery,
London / Galerie de Gestlo, Hamburg **/**
1978 Morgan Gallery, Kansas City **/**
1979 Aldrich Museum of Contemporary Art,
Ridgefield, Connecticut / Galerie de Gestlo,
Cologne / Delta Gallery, Rotterdam /
Getler-Pall Gallery, New York **/**
1980 Thomas Segal Gallery, Boston / Ball
State University, Muncie / Madison Art
Center, Wisconsin / Carlson Gallery,
University of Bridgeport, Connecticut /
Barbara Fendrick Gallery, Washington,
D.C. **/** 1981 Mattatuck Museum,
Waterbury **/** 1982 Coe Kerr Gallery, New
York.

Selected Group Exhibitions

1966 *Newport Harbor Annual,* Newport
Harbor Art Museum, Newport Beach **/**
1969 *The Persistent Image,* Fresno State
College **/** 1970 *The Highway,* Institute of
Contemporary Art, University of
Pennsylvania, Philadelphia / *The Cool
Realists,* Jack Glenn Gallery, Corona del Mar
/ *Beyond the Actual: Contemporary
California Realist Painting,* Pioneer
Museum, Stockton **/** 1971 *Radical Realism,*
Museum of Contemporary Art, Chicago /
New Realism, State University of New York,
Potsdam **/** 1972 *The State of California
Painting,* Govett-Brewster Art Gallery, New
Plymouth, New Zealand / *In Sharp-Focus,*
Sidney Janis Gallery, New York /
Documenta V, Kassel (catalogue) / *14 Los
Angeles Painters,* The Art Galleries,
University of California, Santa Barbara /
Realism Now, New York Cultural Center **/**
1972-1973 *Amerikanischer Fotorealismus,*
Württembergischer Kunstverein, Stuttgart
(catalogue and tour) **/** 1973 *Photo Realism,*
Serpentine Gallery, London / *Realism Now,*
New York Cultural Center **/**

Katonah Gallery, Katonah, New York / *Grands Maîtres Hyperréalistes Américains,* Galerie des 4 Mouvements, Paris / *Amerikanske Realister,* Randers Kunstmuseum, Sweden / *Image, Reality and Superreality,* Arts Council of Great Britain (catalogue and tour) / *Hyperréalisme,* Galerie Isy Brachot, Brussels / *Separate Realities,* Municipal Art Gallery, Los Angeles (catalogue) **/** 1974 *Kijken Naar de Werkelijkheid,* Museum Boymans-van Beuningen, Rotterdam / *New Photo Realism,* Wadsworth Atheneum, Hartford / *Hyperréalistes Américains – Réalistes Européens,* Centre National d'Art Contemporain, Paris / *Tokyo Biennale* (catalogue) **/** 1975 *Image, Color and Form, Recent Paintings by Eleven Americans,* Toledo Museum of Art / *Realismus und Realität,* Kunsthalle, Darmstadt / *Signs of Life; Symbols in the City,* Renwick Gallery, Smithsonian Institution, Washington, D.C. / *Super Realism,* Baltimore Museum of Art **/** 1976 *America as Art,* National Collection of Fine Arts, Washington, D.C. / *Photo Realist Watercolors,* Neuberger Museum, State University of New York, Purchase / *Group Exhibition,* Boehm Gallery, Palomar College, San Marcos, California (catalogue) **/** 1977 *Illusion and Reality,* Australian National Gallery, Canberra (catalogue and tour) **/** 1978 *Art About Art,* Whitney Museum of American Art, New York (catalogue) **/** 1980 ROSC, Dublin / *Realism/Photo-Realism,* Philbrook Art Center, Tulsa (catalogue) / *The Morton G. Neumann Family Collection,* National Gallery of Art Washington, D.C. (catalogue and tour) **/** 1981 *Real, Really Real, Super Real,* San Antonio Museum of Art (catalogue and tour) / *Contemporary American Realism since 1960,* Pennsylvania Academy of the Fine Arts, Philadelphia (catalogue and tour) / *Drawing Acquisitions, 1978-1981,* Whitney Museum of American Art, New York **/** 1982 *Realist Drawings, Watercolors and Prints: Contemporary Works on Paper,* Gross McCleaf Gallery, Philadelphia / *American Realism,* Coe Kerr Gallery, New York.

Selected Reading

Battcock, Gregory and Toni del Renzio. "New York Developments: Robert Cottingham, The Capers of the Signscape," *Art and Artist,* vol. 9, February 1975, pp. 4-13.

Chase, Linda and Ted McBurnett. "The Photo Realists: 12 Interviews," *Art in America,* vol. 60, November/December 1972, pp. 77-78.

Cottingham, Jane. "Techniques of Three Photo-Realist Painters," *American Artist,* vol. 44, February 1980, p. 62.

Karp, Ivan. "Rent is the Only Reality, The Hotel Instead of the Hymn," *Arts Magazine,* vol. 46, December 1971, pp. 47-51.

Melville, Robert. "The Photograph as Subject," *Architectural Review,* vol. 153, May 1973, pp. 329-332.

Schjeldahl, Peter. "Too Easy to Be Art," *The New York Times,* 12 May 1974, p. 23.

Wilmer, Denise. "In the Galleries, Sharp-Focus Realism," *Arts Magazine,* March 1972, pp. 57-58.

19 Cottingham, *The Spot,* 1982

Rackstraw Downes

Born 1939, Kent, England. Received B.A. from Cambridge University, 1961; M.F.A. from Yale School of Art and Architecture, 1964. Lives in New York and Maine.

20 Downes, *Sprowl's Lumber Yard,* 1976

Selected Individual Exhibitions

1969 Swarthmore College, Philadelphia / 1972, 1974, 1975, 1978, 1980 Kornblee Gallery, New York / 1978 Swain School of Design, New Bedford / 1980 Tatistcheff & Company, New York.

Selected Group Exhibitions

1968 *Painterly Realism,* American Federation of the Arts (catalogue and tour) / 1972 *Painters of Land and Sky,* Picker Gallery, Colgate University, Hamilton, New York (catalogue and tour) / 1973 *A Sense of Place, The Artist and the American Landscape,* Mid-America Arts Alliance (catalogue and tour) / 1975 *New Images in American Figurative Painting,* Squibb Gallery, Princeton / 1976 *Skowhegan,* Institute of Contemporary Art, Boston / 1977 *Childe Hassam Purchase Exhibition,* American Academy of Arts & Letters, New York / 1978 *The Landscape, Different Points of View,* Wave Hill, Riverdale, New York / *Things Seen,* Sheldon Memorial Art Gallery, University of Nebraska, Lincoln ((catalogue and tour) / *Landscape/Cityscape,* State University of New York, Potsdam / 1979 *The New Concern with Nature,* Staten Island Museum, New York / 1980 *The*

Figurative Image, Hartford Art School, University of Hartford / 1980-1981 *American Drawings in Black and White, 1970-1980,* The Brooklyn Museum, New York (brochure) / 1981 *Real, Really Real, Super Real,* San Antonio Museum of Art (catalogue and tour) / *20 Artists: Yale School of Art 1950-1970,* Yale University Art Gallery, New Haven / *The Americans: The Landscape,* Contemporary Arts Museum, Houston / *Contemporary American Landscape,* Hirschl & Adler Galleries, New York / *The Panoramic Image,* University of Southampton, England / *Biennial Exhibition,* Whitney Museum of American Art, New York (catalogue) / *Contemporary American Realism since 1960,* Pennsylvania Academy of the Fine Arts, Philadelphia (catalogue and tour) / 1982 *Points of View: 1982,* Museum of Art, University of Oklahoma, Norman / *An Appreciation of Realism,* Museum of Art, Munson-Williams-Proctor Institute, Utica / *Carnegie International,* Carnegie Institute, Pittsburgh.

Selected Reading

Bourdon, David, "Rackstraw Downes," *Arts Magazine,* vol. 52, February 1978, p. 3.

Downes, Rackstraw. "What the Sixties Meant to Me," *Art Journal,* vol. 34, Winter 1974/75, pp. 125-131.

————. "Post-Modernist Painting," *Tracks,* vol. 2, Fall 1976, pp. 70-73.

————. "Fairfield Porter: The Painter as Critic," *Art Journal,* vol. 37, Summer 1978, pp. 306-312.

Martin, J. "Rackstraw Downes," *Arts Magazine,* vol. 55, October 1981, p. 4.

Nochlin, Linda. "Rackstraw Downes at Kornblee," *Art in America,* vol. 64, January 1976, pp. 101-102.

21 Downes, *Looking up 107th,* 1978

Martha Mayer Erlebacher

Born 1937, Jersey City, New Jersey. Attended Gettysburg College, 1955-1956; received B.I.D., 1960, and M.F.A., 1963, Pratt Institute. Lives in Pennsylvania.

Selected Individual Exhibitions

1967 The Other Gallery, Philadelphia / 1973, 1975, 1978, 1979 Robert Schoelkopf Gallery, New York / 1976 Dart Gallery, Chicago / 1978 Pennsylvania Academy of the Fine Arts, Philadelphia.

Selected Group Exhibitions

1967 *Self-Portraits,* Philadelphia Art Alliance / 1969 *New Realism,* St. Cloud State College, Minnesota / 1971 *The Contemporary Figure, A New Realism,* Suffolk Museum, Stony Brook (catalogue) / 1972 *Realism Now,* New York Cultural Center / *American Drawing, 1970-1973,* Yale University Art Gallery, New Haven / 1974 *Living American Artists and the Figure,* Museum of Art, Pennsylvania State University, University Park / 1975 *The Nude in American Art,* New York Cultural Center / 1976 *American Figure Drawing,* Lehigh University, Bethlehem, Pennsylvania; Melbourne and Adelaide, Australia (catalogue) / *Philadelphia — Three Centuries of American Art,* Philadelphia Museum of Art (catalogue) / *The Figure in Drawing Now,* Bennington College, Vermont / 1977 *Still Life, Recent Drawings and Watercolors,* Boston University Art Gallery / *Contemporary Pastels and Watercolors,* Indiana University Art Museum, Bloomington / *Drawings of the Seventies,* The Art Institute of Chicago / 1979 *Contemporary Drawings: Philadelphia II,* Philadelphia Museum of Art / *The Watercolor Still Life,* Gladstone-Villani, New York / *Drawing Now,* Impressions Gallery, Boston / 1970 *Realism and Metaphor,* University of South Florida Gallery, Tampa (catalogue) / 1980-1981 *American Drawings in Black and White, 1970-1980,* The Brooklyn Museum, New York / 1981 *Self-Portraits,* Barbara Fendrick Gallery, Washington, D.C. / *Contemporary Figure Drawings,* Robert Schoelkopf Gallery, New York / *Contemporary American Realism since 1960,* Pennsylvania Academy of the Fine Arts, Philadelphia (catalogue and tour).

Selected Reading

Galassi, Susan. "Martha Mayer Erlebacher," *Arts Magazine,* vol. 54, March 1980, p. 23.

Jarmusch, Ann. "Philadelphia: Apples for Adam and Eve," *ARTnews,* vol. 77, December 1978, p. 122.

Kramer, Hilton. "Martha Mayer Erlebacher," *The New York Times,* 4 January 1980, p. 16.

————. "Martha Mayer Erlebacher," *The New York Times,* 10 May 1980, p. 25.

Laderman, Gabriel. "Martha Mayer Erlebacher at Schoelkopf," *Art in America,* vol. 63, September/October 1975, p. 100.

Lubell, Ellen. "In Praise of the Figure: The Paintings of Martha Mayer Erlebacher," *Arts Magazine,* vol. 52, October 1978, pp. 138-141.

Russell, John. "Martha Mayer Erlebacher," *The New York Times,* 6 January 1973, p. 25.

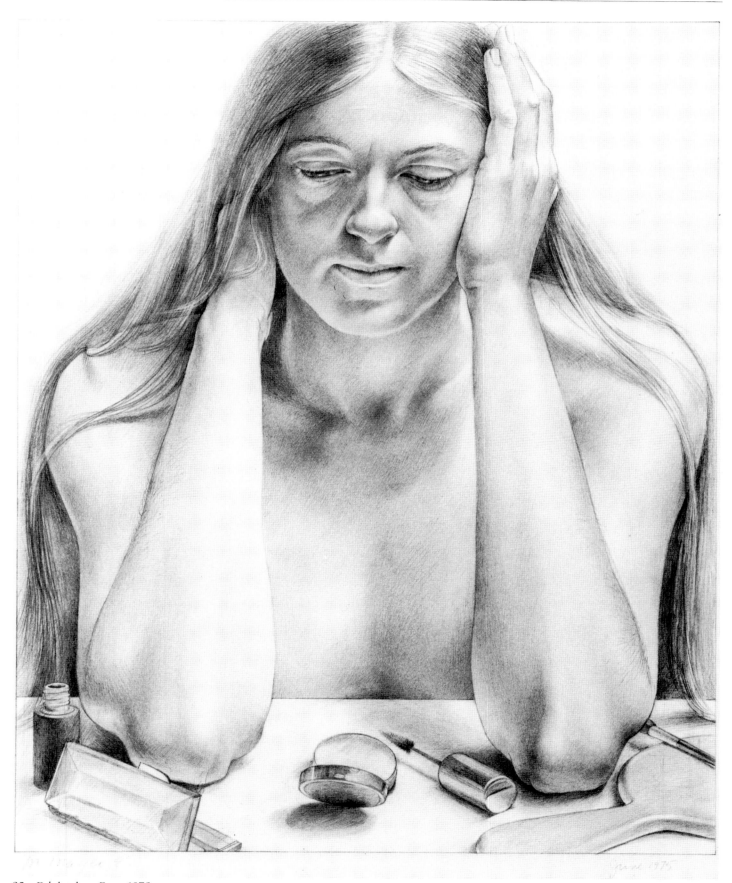

25 Erlebacher, *Face*, 1975

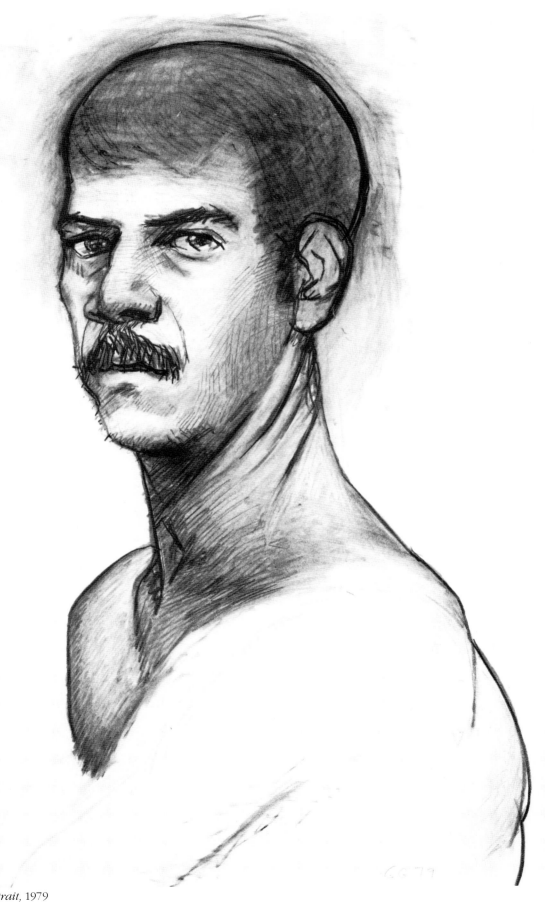

28 Gillespie, *Self-Portrait*, 1979

Born 1936, Roselle Park, New Jersey.
Attended Cooper Union, New York; received
B.A. and M.F.A. from San Francisco Art
Institute. Lives in Massachusetts.

Selected Individual Exhibitions

1966, 1968, 1970, 1972, 1973, 1976,
1979 Forum Gallery, New York /
1969 American Academy, Rome /
1970 Georgia Museum of Art, Athens /
1971 Alpha Gallery, Boston / 1974 Galleria
il Fante di Spade, Rome / Smith College
Museum of Art, Northampton /
1977 Hirshhorn Museum and Sculpture
Garden, Smithsonian Instition, Washington,
D.C. / 1980 University of Bridgeport,
Connecticut / 1982 Georgia Museum of
Art, Athens / Smith College Museum of Art,
Northampton.

Selected Group Exhibitions

1978 *153rd Annual Exhibition,* National
Academy of Design, New York / *American
Academy in Rome,* Union Carbide Building,
New York / 1979 *The Opposite Sex: A
Realistic Viewpoint,* University of Missouri,
Kansas City / *Whitney Biennial,* Whitney
Museum of American Art, New York
(catalogue) / *154th Annual Exhibition,*
National Academy of Design, New York /
Uncommon Visions, University of
Rochester, New York / *Things Seen: The
Concept of Realism in 20th Century
American Painting,* Sheldon Memorial Art
Gallery, University of Nebraska, Lincoln /
Portraits of the Sixties/Seventies, Aspen
Center for Visual Art / *Great American
Story-Tellers,* Oklahoma Art Center,
Oklahoma City / 1980 *The Figurative
Image,* Hartford School of Art, University of
Hartford / *New York Realists,* Thorpe
Intermedia Gallery, Sparkhill, New York
(catalogue) / *Images in Landscape: The Last
Decade,* University of New Hampshire,
Durham / *Mystical and Magical Realism,*
Aldrich Museum of Contemporary Art,
Ridgefield, Connecticut / *American Realism
of the Twentieth Century,* Morris Museum of
Arts and Sciences, Morristown, New Jersey /
First Person Singular: Recent Self-Portraits,
Pratt Institute, New York /
1981 *Contemporary American Realism
since 1960,* Pennsylvania Academy of the
Fine Arts, Philadelphia (catalogue and tour).

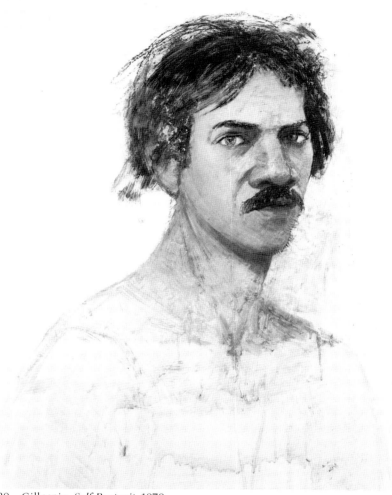

29 Gillespie, *Self-Portrait,* 1979

Gregory Gillespie

Selected Reading

Betz, Margaret. "Gregory Gillespie,"
ARTnews, vol. 76, January 1977, p. 126.

Brown, Pamela. "Gregory Gillespie," *Arts
Magazine,* vol. 51, February 1977, p. 11.

Gillespie, Gregory. *Gregory Gillespie,
Paintings (Italy 1962-1970).* New York:
Forum Gallery, 1970.

———— and Oriole Farb. "Self-Portraits,
Gregory Gillespie," *Massachusetts Review,*
vol. 19, Spring 1978, pp. 129-140.

Lerner, Abram. *Gregory Gillespie* (exh. cat.).
Washington, D.C.: Hirshhorn Museum and
Sculpture Garden, Smithsonian Institution
Press, 1977.

Ratcliff, Carter. "New York Letter, Gregory
Gillespie," *Art International,* vol. 22,
November 1978, pp. 63-64.

D.J. Hall

Born 1951, Los Angeles. Received B.F.A. from
University of Southern California, 1973.
Lives in California.

Selected Individual Exhibitions

1977 Albert Contreras Gallery,
Los Angeles / 1981, 1982 O.K. Harris Works
of Art, New York / 1981 Guggenheim
Gallery, Chapman College, Orange,
California.

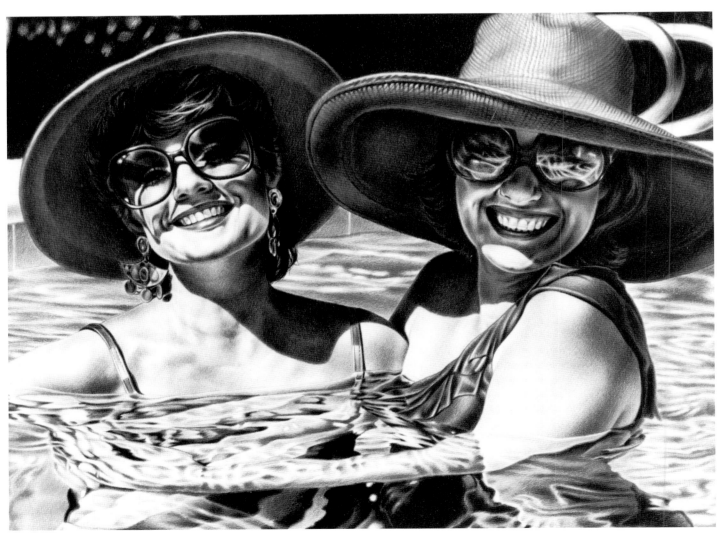

32 Hall, *Too Pretty to Worry,* 1982

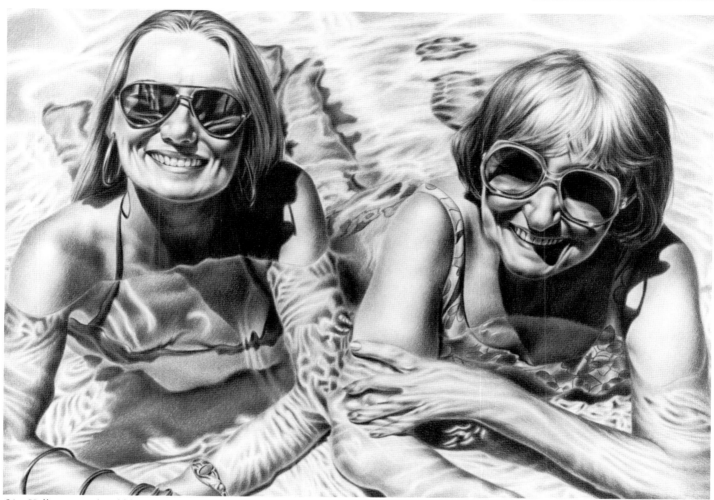

31 Hall, *Jan and Bubbles*, 1982

Selected Group Exhibitions

1977 *Billboards,* Eyes and Ears Foundation, Los Angeles / 1978 *Figurative Realism '78,* Occidental College, Los Angeles / *Realist Painters, Los Angeles,* Arco Center for the Visual Arts, Los Angeles / *100+ Current Directions in Southern California Art,* Los Angeles Institute of Contemporary Art / 1979 *Portraits/1979,* Municipal Art Gallery, Los Angeles / *Recent Los Angeles Painting,* Lang Art Gallery, Scripps College, Claremont / 1980 *Photo-Realist Painting in California: A Survey,* Santa Barbara Museum of Art (brochure) / 1981 *Be My Valentine,* Delaware Museum of Art, Wilmington / *Decade — Los Angeles Painting in the Seventies,* Art Center College of Design, Pasadena (catalogue) / *Changes: Art in America 1881/1981,* Marquette University, Milwaukee (catalogue) / *Contemporary American Realism since 1960,* Pennsylvania Academy of the Fine Arts, Philadelphia (catalogue and tour) / 1982 *Group Exhibition,* Boehm Gallery, Palomar College, San Marcos, California (catalogue) / *The Real Thing,* Laguna Beach Museum of Art (catalogue).

Selected Reading

Ballatore, Sandy. "Decade/Los Angeles Painting in the Seventies," *Images and Issues,* vol. 2, Summer 1981, pp. 40-43.

Clothier, Peter. "Looking at Others," *Artweek,* vol. 10, 12 May 1979, p. 3.

Hazlitt, Gordon J. "Review," *ARTnews,* vol. 76, September 1977, pp. 112-120.

Muchnic, Suzanne. "Art Moves Outdoors," *Artweek,* vol. 8, 19 February 1977, p. 1.

———. "Symbiosis of Canvas and Camera," *Los Angeles Times,* 1 April 1978, Part II, p. 11.

Wilson, William. "Art Walk," *Los Angeles Times,* 8 April 1977, Part IV, p. 8.

———. "Figurative Photos Meet the Abstract," *Los Angeles Times,* 27 April 1980, Calendar, pp. 93-95.

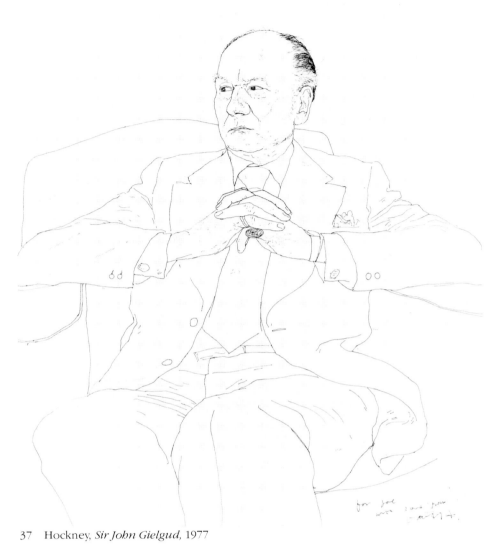

37 Hockney, *Sir John Gielgud*, 1977

David Hockney

Born 1937, Bradford, England. Attended Bradford College of Art, 1953-1957; Royal College of Art, London, 1959-1962. Lives in London and California.

Selected Individual Exhibitions

1963, 1965, 1966, 1968, 1970, 1972 Kasmin Gallery, London / 1966 Stedelijk Museum, Amsterdam / Palais des Beaux-Arts, Brussels / 1968 Landau-Alan Gallery, New York / 1969, 1970, 1972, 1973, 1977, 1980, 1981 André Emmerich Gallery, New York / 1970 The Whitechapel Art Gallery, London / Galerie Springer, Berlin / 1971 Kunsthalle Bielefeld / 1977 Galerie Neuendorf, Hamburg / 1978-1980 *David Hockney: Travels with Pen, Pencil and Ink,* Yale Center for British Art (catalogue and tour) / 1978 Waddington Galleries, Toronto / *David Hockney: Drawings and Prints,* Albertina, Vienna (catalogue and tour) / 1979 Museum of Modern Art, New York / M.H. de Young Memorial Museum, San Francisco / Bradford Art Galleries and Museum, Bradford, England.

Selected Group Exhibitions

1960 *London Group,* RBA Galleries, London / 1962 *Four Young Artists,* Institute of Contemporary Arts, London / *Kompass II,* Stedelijk Museum, Eindhoven / 1963 *British Painting in the Sixties,* Tate Gallery and The Whitechapel Art Gallery, London (catalogue) / 1964 *British Painters of Today,* Kunsthalle, Düsseldorf (catalogue and tour) / *International Exhibition of Drawings,* Mathildenhöhe, Darmstadt / 1965 *London: The New Scene,* Walker Art Center, Minneapolis (catalogue and tour) / 1967 *Drawing Towards Painting,* Arts Council of Great Britain, London / *Documenta IV,* Kassel (catalogue) / 1968 *XXXIV Biennale,* Venice (catalogue) / 1969 *Pop Art Redefined,* Hayward Gallery, London (catalogue) / 1974 *David Hockney, Paintings and Drawings,* British Council for Musée des Arts Décoratifs, Paris / 1975 *European Painting in the Seventies,* Los Angeles County Museum of Art / 1976 *Peter Blake, Richard Hamilton, David Hockney, R.B. Kitaj, Eduardo Paolozzi,* Museum Boymans-van Beuningen, Rotterdam (catalogue) / 1977 *A View of the Figure in Drawing, 1970's,* University of Bridgeport, Connecticut / 1980 *Contemporary Drawings and Watercolors,* Memorial Art Gallery of the University of Rochester, New York / 1981 *Westkunst,* Museen der Stadt, Cologne (catalogue) / 1982 *Carnegie International,* Carnegie Institute, Pittsburgh.

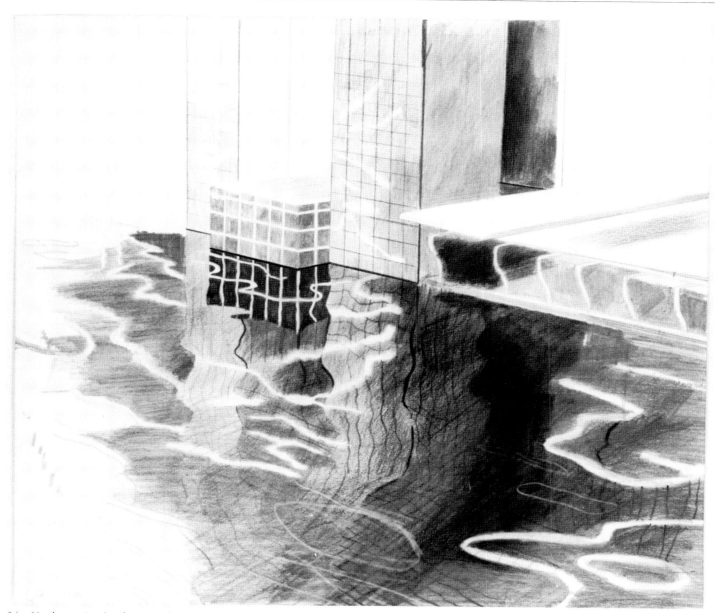

34 Hockney, *Study of Water, Phoenix, Arizona, No. 14*, 1976

Selected Reading

del Renzio, Toni. "Style, Technique and Iconography," *Art and Artist,* vol. 34, July 1976, pp. 34-39.

Geelhaar, Christian. "Looking at Pictures with David Hockney," *Pantheon,* vol. 36, July 1978, pp. 230-239.

Hockney, David. *David Hockney.* ed. Nikos Stangos with introduction by Henry Geldzahler. New York: Harry N. Abrams, 1976.

————. "R.B. Kitaj and David Hockney Discuss the Case for a Return to the Figurative . . .," *New Review,* January/February 1977, pp. 75-77.

————. *David Hockney, Paper Pools.* ed. Nikos Stangos. New York: Harry N. Abrams, 1980.

Livingstone, Marco. *David Hockney.* London: Thames and Hudson, 1981.

Oliver, G. "David Hockney," *Connaissance des Arts,* vol. 273, November 1974, p. 144.

R.B. Kitaj

Born 1932, Chagrin Falls, Ohio. Attended Akademie der Bildenden Künste, Vienna, 1951-1954; received C.F.A., Oxon, Ruskin School of Drawing and Fine Art, 1959; Diploma, Royal College of Art, 1962. Lives in England.

Selected Individual Exhibitions

1963 Marlborough New London Gallery, London (catalogue) / 1965 Marlborough-Gerson Gallery, New York (catalogue) / 1967 Cleveland Museum of Art / University of California, Berkeley / 1970 Kestner-Gesellschaft, Hanover; Boymans-van Beuningen Museum, Rotterdam (catalogue and tour) / 1974 Marlborough Gallery, New York (catalogue) / 1977 Marlborough Fine Art, London / 1979 Marlborough Gallery, New York (catalogue) / 1980 Marlborough Fine Art, London (catalogue) / 1981 Hirshhorn Museum and Sculpture Garden, Smithsonian Institution, Washington, D.C. (catalogue and tour).

Selected Group Exhibitions

1958 *Young Contemporaries 1958*, RBA Galleries, London (catalogue) / 1960 *Young Contemporaries 1960*, RBA Galleries, London / 1961 *Young Contemporaries 1961*, Royal College of Art, London (catalogue) / 1963 *British Painting in the Sixties*, Tate Gallery and The Whitechapel Art Gallery, London (catalogue) / 1964 *Guggenheim International Award 1964*, Solomon R. Guggenheim Museum, New York (catalogue and tour) / *XXXII Biennale*, Venice (catalogue) / *Documenta III*, Kassel (catalogue) / 1967 *Visage de l'homme dans l'art contemporain*, Musée Rath, Geneva (catalogue) / *Pictures to be Read / Poetry to be Seen*, Museum of Contemporary Art, Chicago (catalogue) / 1968 *Social Comment in America*, Museum of Modern Art, New York (brochure and tour) / *The Obsessive Image 1960-1968*, Institute of Contemporary Art, London (catalogue) / *Peintres européens d'aujourd'hui*, Musée des Arts Décoratifs, Paris (catalogue) / 1969 *Information: Tilson, Phillips, Jones, Paolozzi, Kitaj, Hamilton*, Kunsthalle, Basel (catalogue) / *Pop Art Redefined*, Hayward Gallery, London (catalogue) / 1970 *XXXV Biennale*, Venice (catalogue) / 1971 *De Metamorfose van het Object: Kunst en anti-Kunst 1910-1970*, Musées Royaux des Beaux-Arts de Belgique, Brussels (catalogue and tour) / *The Artist as Adversary: Works from the Museum Collection*, Museum of Modern Art, New York (catalogue) / 1973 *Dine, Kitaj*, Cincinnati Art Museum (catalogue) / 1975 *European Painting in the Seventies*, Los Angeles County Museum of Art (catalogue) / 1976 *Peter Blake, Richard Hamilton, David Hockney, R.B. Kitaj, Eduardo Paolozzi*, Museum Boymans-van Beuningen, Rotterdam (catalogue) / 1979 *Lives: An Exhibition of Artists Whose Work is Based on Other People's Lives*, Serpentine Gallery, London (catalogue) / *This Knot of Life*, L.A. Louver Gallery, Venice, California, Part 2 (catalogue) / 1980 *Realism and Metaphor*, University of South Florida Gallery, Tampa (catalogue) / 1981 *Drawings and Watercolors by 13 British Artists*, Marlborough Fine Art, London (catalogue).

Selected Reading

Kitaj, R.B. "Painters' Reply," *Artforum*, vol. 14, September 1975, p. 28.

_____. "School of London," *The Human Clay: An Exhibition Selected by R.B. Kitaj* (exh. cat.). London: British Arts Council, 1976.

_____. "R.B. Kitaj and David Hockney Discuss the Case for a Return to the Figurative . . .," *New Review*, February 1977, pp. 75-77.

Phillpot, Clive. "Kitaj Retrospective," *Art Journal*, vol. 42, Spring 1982, pp. 55-57.

Podro, Michael. "Some Notes on Ron Kitaj," *Art International*, vol. 22, March 1979, pp. 18-26.

Roberts, Keith. "R.B. Kitaj," *Burlington Magazine*, vol. 112, June 1970, pp. 416-418.

Shannon, Joe and John Ashbery, Jane Livingston, R.B. Kitaj, and Timothy Hyman. *R.B. Kitaj* (exh. cat.). Washington, D.C.: Hirshhorn Museum and Sculpture Garden, Smithsonian Institution Press, 1981.

Tuten, Frederic. "Neither Fool, Nor Naive, Nor Poseur-Saint: Fragments on R.B. Kitaj," *Artforum*, vol. 20, January 1982, pp. 61-69.

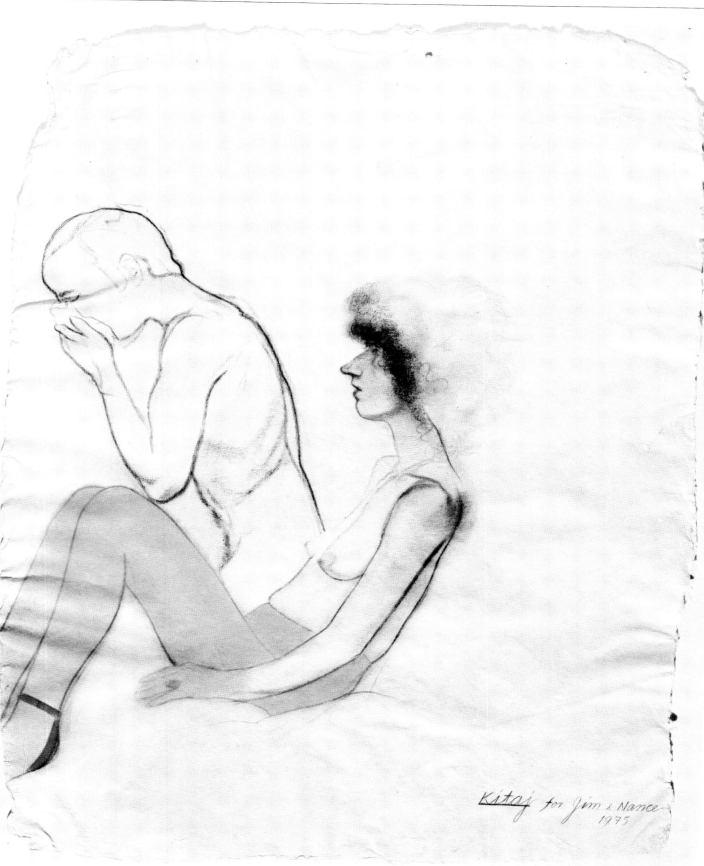

39 Kitaj, *The Sneeze,* 1975

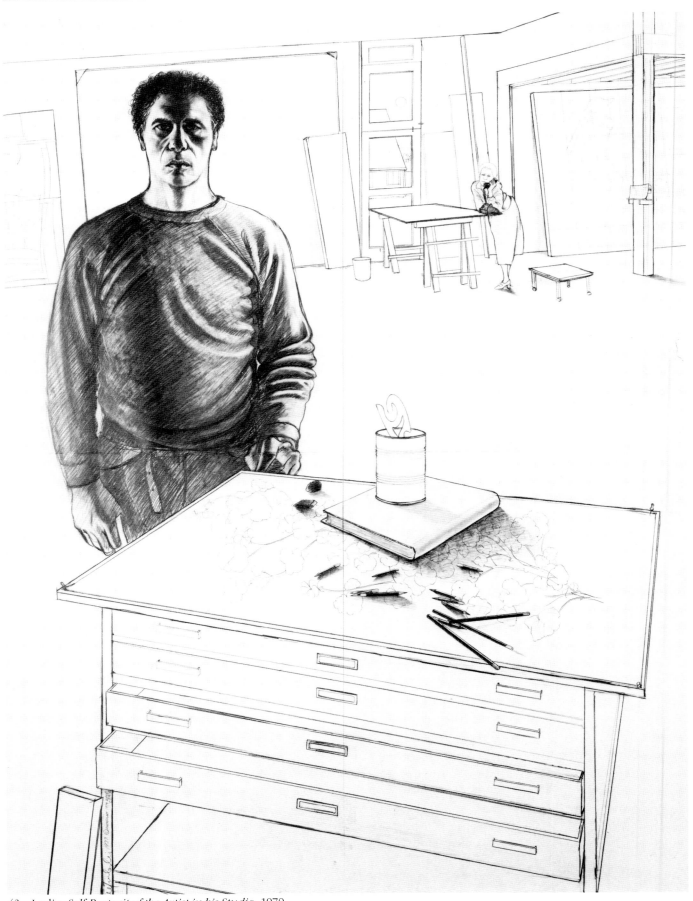

43 Leslie, *Self-Portrait of the Artist in his Studio,* 1979

Born 1927, Bronx, New York. Attended New York University and the Art Students League. Lives in Massachusetts.

Selected Individual Exhibitions

1969, 1971 Noah Goldowsky Gallery, New York / 1975, 1978, 1980 Allan Frumkin Gallery, New York / 1976-1977 Museum of Fine Arts, Boston (catalogue and tour) / 1977 Kilcawley Center Art Gallery, Youngstown State University / Allan Frumkin Gallery, Chicago / 1978 Jorgensen Gallery, University of Connecticut.

Selected Group Exhibitions

1967 *Recent Figurative Art,* Bennington College, Vermont / 1968 *Realism Now,* Vassar College Art Gallery, Poughkeepsie (catalogue) / *The Poems of Frank O'Hara,* Museum of Modern Art, New York / 1970 *22 Realists,* Whitney Museum of American Art, New York (catalogue) / 1971 *Leslie, Thiebaud, Pearlstein,* Hayden Gallery, Massachusetts Institute of Technology, Cambridge / 1973 *American Drawings 1963-1973,* Whitney Museum of American Art, New York / *Drawings by Seven Realists,* Harcus-Krakow Gallery, Boston / 1975 *Watercolors and Drawings: American Realists,* Meisel Gallery, New York / *The Portrait,* Boston University Art Gallery / 1976 *The Figure in Drawing Now,* Bennington College, Vermont / *XXXVII Biennale,* Venice (catalogue) / 1977 *Contemporary Pastels and Watercolors,* Indiana University Art Museum, Bloomington / *Drawings of the 70's,* Museum of Modern Art, New York / 1977-1978 *Recent Works on Paper by American Artists,* Madison Art Center, Wisconsin / *8 Contemporary American Realists,* Pennsylvania Academy of the Fine Arts, Philadelphia (catalogue) / 1979 *Images of the Self,* Hampshire College Art Gallery, Massachusetts / 1980 *American Portrait Drawings,* National Portrait Gallery, Washington, D.C. / 1980-1981 *American Drawings in Black and White, 1970-1980,* The Brooklyn Museum, New York (brochure) / *Realism/Photo-Realism,* Philbrook Art Center, Tulsa (catalogue) / 1981-1982 *Real, Really Real, Super Real,* San Antonio Museum of Art (catalogue and tour) / *Contemporary American Realism since 1960,* Pennsylvania Academy for the Fine Arts, Philadelphia (catalogue and tour).

Selected Reading

Ellenzweig, Allan. "Alfred Leslie," *Arts Magazine,* vol. 50, January 1976, p. 22.

Goodyear, Frank, Jr. *8 Contemporary American Realists* (exh. cat.). Philadelphia: Pennsylvania Academy of the Fine Arts, 1977.

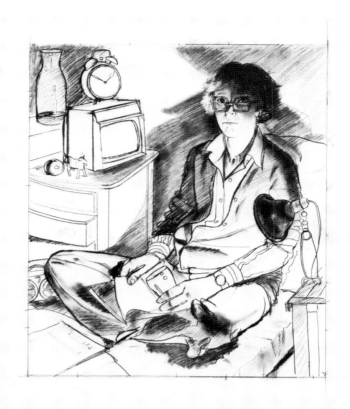

44 Leslie, *Preparatory Drawing for "In the Studio of Gretchen McLaine,"* 1980

Alfred Leslie

Haggerty, Gerard. "Alfred Leslie and the Poetry of the Real," *Alfred Leslie* (exh. cat.). New York: Allan Frumkin Gallery, 1978.

Hulten, Pontus. "Al Leslie: de l'abstraction gesturelle à l'hyperréalisme," *XX Siècle,* vol. 45, December 1975, pp. 98-102.

Leslie, Alfred. Statement by the artist in Gerrit Henry, "Modern American Sampling," *Art in America,* vol. 63, January/February 1975, p. 38.

Marandel, J. Patrice. "The Deductive Image: Notes on Some Figurative Painters," *Art International,* vol. 15, September 1971, pp. 58-61.

Nochlin, Linda. "Leslie, Torres: New Uses of History," *Art in America,* vol. 64, April 1976, pp. 74-76.

Rosenblum, Robert. "Notes on Alfred Leslie," *Alfred Leslie* (exh. cat.). Boston: Museum of Fine Arts, 1976, unpaginated.

David Ligare

Born 1945, Oak Park, Illinois. Attended
Chouinard Art Institute, 1961; Art Center
College of Design, Pasadena, 1964.
Lives in California.

Selected Individual Exhibitions

1969 Wickersham Gallery, New York /
1970 Monterey Museum of Art / 1974,
1978 Andrew Crispo Gallery, New York /
1977 Phoenix Art Museum.

Selected Group Exhibitions

1969, 1970 ACA Galleries, New York /
1971 Minnesota Museum of Art, St. Paul /
Art on Paper, Weatherspoon Art Gallery,
University of North Carolina, Greensboro
(catalogue) / 1972 The Cleveland Institute
of Art / 1973 Andrew Crispo Gallery, New
York / 1974 *Contemporary Painting and
Sculpture,* Krannert Art Museum, University
of Illinois, Champaign (catalogue) /
1976 *Recent Acquisitions,* The Museum of
Modern Art, New York / *Santa Barbara
Drawings,* Santa Barbara Museum of Art
(catalogue) / *The Presence and the Absence
in Realism,* Brainard Art Gallery, State
University of New York, Potsdam
(catalogue) / 1978 *Paintings from New
York Galleries,* Squibb Art Gallery,
Princeton / 1979 *Reality of Illusion,*
Denver Art Museum (catalogue and tour) /
1980 *America and Europe: A Century of
Modern Art from the Thyssen-Bornemisza
Collection* (catalogue and Australian
tour) / 1982 *Modern American Painting:
The Museum of Fine Arts, Houston,* National
Pinokothiki, Athens.

Selected Reading

Bell, Jane. "David Ligare," *Arts Magazine,*
vol. 48, April 1974, p. 70.

Heineman, Susan. "Review," *Artforum,*
vol. 12, April 1974, pp. 80-81.

Battcock, Gregory, ed. *Super Realism: A
Critical Anthology.* New York: E.P. Dutton,
1975, p. 284.

Clothier, Peter. "The Magic of the Possible:
Five California Artists," *Artforum,* vol. 15,
April 1977, pp. 28-29.

Andrews, Coleman. "Art of the State," *New
West Magazine,* vol. 6, January 1981, p. 56.

45 Ligare, *Ideal Head,* 1980

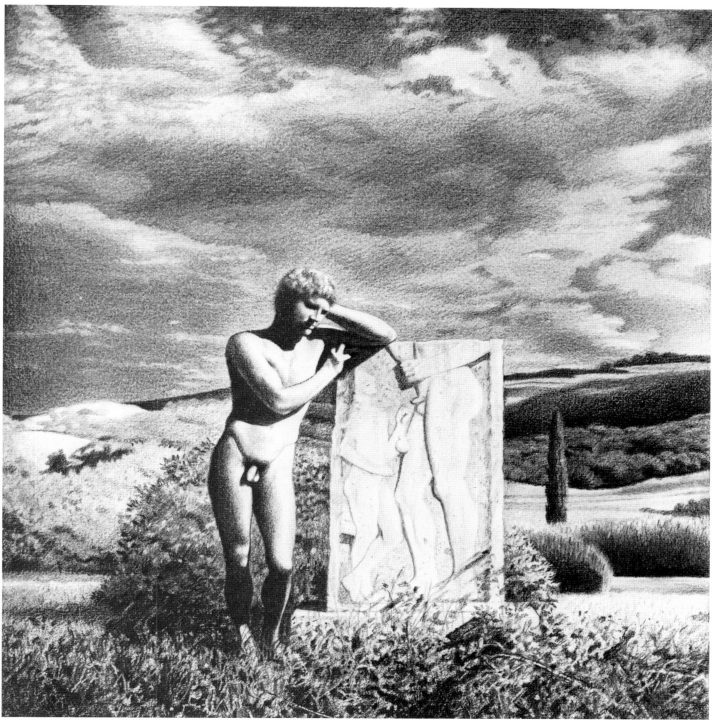

47 Ligare, *Et in Arcadia Ego,* 1981

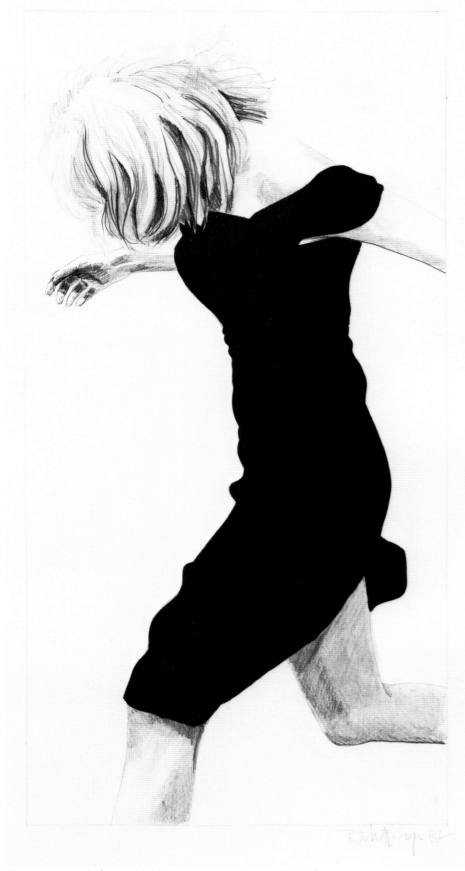

52 Longo, *Study for Final Life Series (Men in the Cities),* 1982

Born 1953, Brooklyn, New York. Attended North Texas State University, Denton; Nassau Community College, New York; received B.F.A. from State University College, Buffalo, 1972. Lives in New York.

Selected Individual Exhibitions

1976 *Artful Dodger/L'Espace Comme Fiction,* Hallwalls, Buffalo / 1979 *Boys Slow Dance,* The Kitchen, New York / 1980 Studio Cannaviello, Milan / 1981 Metro Pictures, New York / Fine Arts Center, University of Rhode Island, Kingston / Larry Gagosian Gallery, Los Angeles / 1982 Texas Gallery, Houston.

Selected Group Exhibitions

1975 *Working on Paper,* Hallwalls Opening Exhibition, Buffalo / 1976 *Convergence and Dispersal,* Albright-Knox Art Gallery, Buffalo / 1977 *Pictures,* Artists Space, New York (catalogue and tour) / 1978 N.A.M.E. Gallery, Chicago / 1979 Hal Bromm Gallery, New York / 1980 *Extensions: Jennifer Bartlett, Lynda Benglis, Robert Longo, Judy Pfaff,* Contemporary Art Museum, Houston (catalogue) / *Illustration & Allegory,* Brooke Alexander Gallery, New York (catalogue) / *Drawings and Paintings on Paper,* Annina Nosei Gallery, New York / Il Gergo Inquieto, Museo Sant-Agostino, Genoa / *Tableaux,* Wave Hill, New York / *Westkunst: Today Section,* Museen der Stadt, Cologne (catalogue) / *Drawings,* Metro Pictures, New York / *Body Language: Figurative Aspects of Recent Art,* Hayden Gallery, Massachusetts Institute of Technology, Cambridge (catalogue and tour) / *Figures: Forms and Expressions,* Albright-Knox Art Gallery, Buffalo / 1982 *Dynamix,* The Contemporary Arts Center, Cincinnati (catalogue and tour) / *The Human Figure in Contemporary Art,* Contemporary Arts Center, New Orleans / *Eight Artists: The Anxious Edge,* Walker Art Center, Minneapolis / *Body Language, a notebook of contemporary figuration,* University Art Gallery, San Diego State University (catalogue) / *Documenta VII,* Kassel (catalogue) / *A Fatal Attraction: Art and the Media,* The Renaissance Society, University of Chicago (catalogue) / *Drawings,* Blum Helman Gallery, New York.

49 Longo, *Untitled,* 1978

Robert Longo

Selected Readings

Blinderman, Barry. "Robert Longo's 'Men in the Cities': Quotes and Commentary," *Arts Magazine,* vol. 55, March 1981, pp. 92-93.

Crimp, Douglas. "Pictures," *October,* no. 8, Spring 1979, pp. 75-88.

Fox, Howard. "Desire for Pathos: The Art of Robert Longo," *Sun & Moon,* no. 8, Fall 1979, p. 72.

Henry, Gerrit. "Pictures," *ARTnews,* vol. 77, January 1978, p. 143.

Lawson, Thomas. "'Pictures' at Artists Space," *Art in America,* vol. 66, January/February 1978, p. 118.

Levin, Kim. "Robert Longo, Metro Pictures," *Flash Art,* no. 102, March/April 1981, p. 40.

Owens, Craig. "The Allegorical Impulse: Toward a Theory of Postmodernism," *October,* no. 12, Spring 1980, pp. 67-86.

Ratcliff, Carter. "Westkunst, Robert Longo," *Flash Art,* no. 103, Summer 1981, pp. 30-31.

Siegel, Jeanne. "Lois Lane and Robert Longo: Interpretation of Image," *Arts Magazine,* vol. 55, November 1980, pp. 156-157.

Simon, Joan. "Double Takes," *Art in America,* vol. 65, October 1980, p. 115.

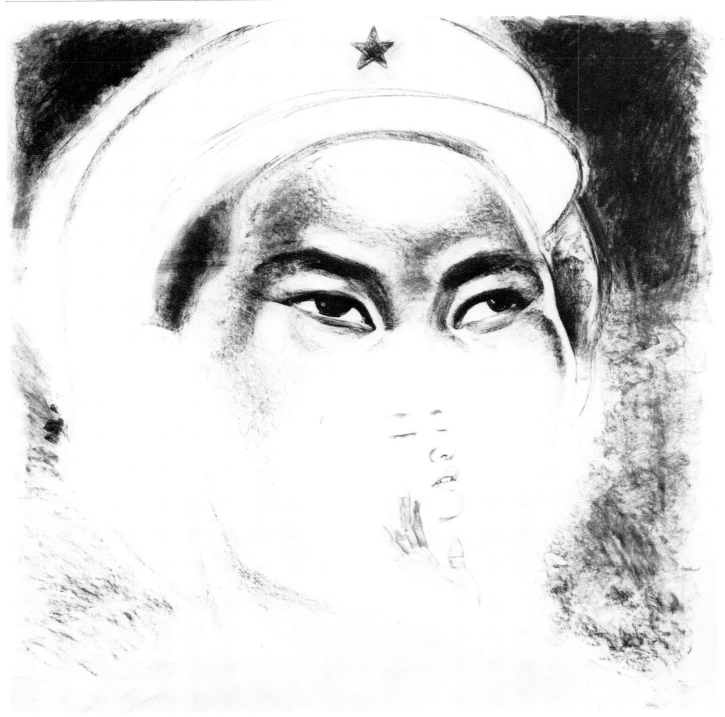

55 Mandel, *Untitled,* 1982

John Mandel

Born 1941, New York. Received B.F.A. from Pratt Institute, 1964. Lives in California.

Selected Individual Exhibitions

1972, 1973, 1975, 1979 Max Hutchinson Gallery, New York / 1978 Thomas/Lewallen Gallery, Santa Monica / 1980 Los Angeles Institute of Contemporary Art / 1983 Koplin Gallery, Los Angeles.

Selected Group Exhibitions

1969 *Whitney Annual,* Whitney Museum of American Art, New York (catalogue) / 1970 Loeb Center, New York University / 1971 *The Contemporary Figure, A New Realism,* Suffolk Museum, Stony Brook (catalogue) / *New Realism,* State University of New York, Potsdam / 1972 *In Sharp-Focus,* Sidney Janis Gallery, New York / Whitney Annual, Whitney Museum of American Art, New York (catalogue) / *Phases of New Realism,* Lowe Art Museum, Coral Gables / *Thirty-two Realists,* Cleveland Art Institute / *Works on Paper,* Max Hutchinson Gallery, New York / 1973 *Options '73,* Contemporary Arts Center, Cincinnati / *American Drawings, 1963-1973,* Whitney Museum of American Art, New York (catalogue) / *National Academy of Design Annual,* New York / 1974 *Living American Artists and the Figure,* Museum of Art, Pennsylvania State University, University Park / 1976 *Presence and Absence in Realism,* State University of New York, Potsdam / 1976-1977 *Genesis of a Gallery, Collection of the Australian National Gallery,* Canberra (catalogue and tour) / 1978 Otis Art Institute, Los Angeles / 1980 Hartford College of Art, University of Hartford / 1981 *Decade, Painting of the 70s in Los Angeles,* Art Center College of Design, Pasadena / *Contemporary Realism,* Brainard Art Gallery, State University of New York, Potsdam (catalogue and tour) / 1982 Newspace Gallery, Los Angeles / *Body Image, a notebook of contemporary figuration,* University Art Gallery, San Diego State University (catalogue) / Baker Gallery, San Diego.

56 Mandel, *Untitled,* 1982

Selected Reading

Borden, Lizzie. "John Mandel," *Artforum,* vol. 10, January 1972, p. 89.

Canaday, John. "Art: The Figure as Defined by Mandel," *The New York Times,* 20 November 1971, p. 27.

_____. "In Mandel's Art, Superb Control," *The New York Times,* 28 April 1973, p. 27.

Nemser, Cindy. "Group Exhibition at Max Hutchinson," *Arts Magazine,* vol. 45, September 1970, p. 64.

_____. "Representational Painting in 1971," *Arts Magazine,* vol. 46, December 1971, pp. 41-46.

Ratcliff, Carter. "New York Letter," *Art International,* vol. 17, Summer 1973, p. 99.

Lubell, Ellen. "John Mandel," *Arts Magazine,* vol. 50, September 1975, p. 19.

Reilly, Richard. "Today's Icons Stir Mental Rumbling," *The San Diego Union,* 23 May 1982.

Wilson, William. "Art Walk," *Los Angeles Times,* 2 October 1978, Part IV, p. 2.

Wortz, Melinda. "Los Angeles: Time, space and the freeway," *ARTnews,* vol. 80, September 1981, pp. 178-179.

Jody Mussoff

Born 1952, Pittsburgh. Attended Corcoran School of Art, 1974-1976; Carnegie-Mellon University, 1970-1971. Lives in Washington, D.C.

Selected Individual Exhibitions

1980 Gallery K, Washington, D.C. **/** 1981, 1983 Monique Knowlton Gallery, New York.

Selected Group Exhibitions

1976 *Paper — An Invitational Exhibition,* Michael C. Rockefeller Arts Center Gallery, State University of New York, Fredonia **/** 1978 Gallery K, Washington, D.C. **/** 1979 *Drawings,* Gallery K, Washington, D.C. / *Inside-Outside,* Women's National Bank, Washington, D.C. / *Elements of Art Texture,* Arlington Arts Center, Arlington, Virginia **/** 1980 *New Talent Show,* Monique Knowlton Gallery, New York **/** 1981 *New Figures,* Hadler-Rodriguez Gallery, Houston / *Claudia Portraits,* Washington Project for the Arts, Washington, D.C. / *Points of View,* Museum of Art, University of Oklahoma, Norman / *Washington Artists,* University of Houston / *2nd International Trienniale of Emerging Artists,* Kunsthalle, Nuremberg (catalogue).

Selected Reading

Fleming, Lee. "Gallery K's Dog Show," *Images & Issues,* vol. 1, Spring 1981, p. 80.

Heller, Nancy G. "The Figure," *Arts Magazine,* vol. 57, January 1983, pp. 46-47.

Hess, Elizabeth. "Mussoff's Private Lives," *The Village Voice,* 4-10 February 1981, p. 54.

Larson, Kay. "Art, The Game of the Rules," *New York Magazine,* vol. 14, 2 February 1981, p. 54.

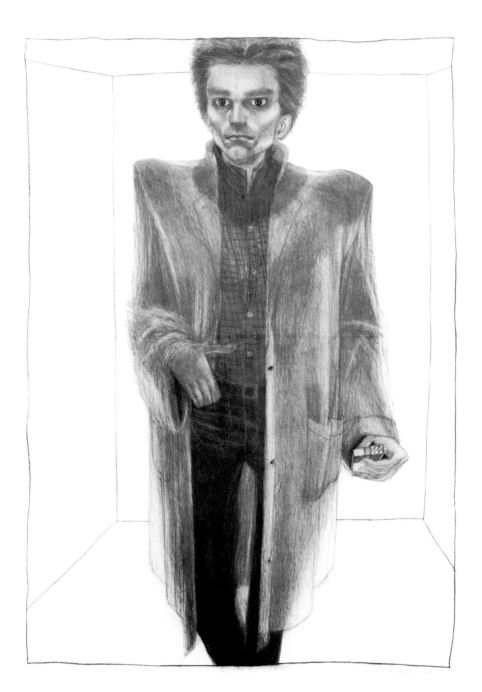

58 Mussoff, *Joseph,* 1980

60 Mussoff, *Two Girls Praying,* 1981

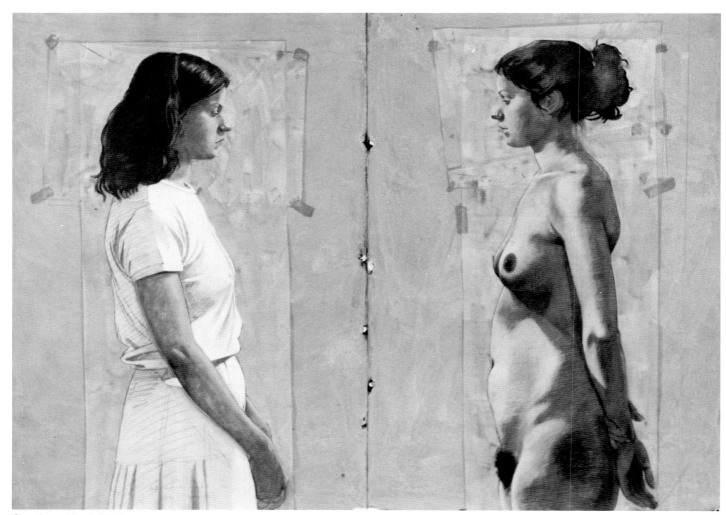

61 Nava, *No. 4,* 1980

John Nava

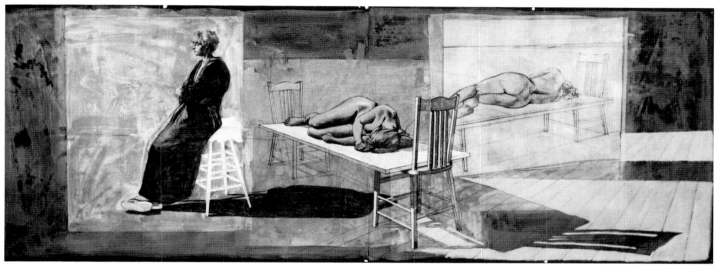

63 Nava, *No. 5,* 1982

Born 1947, San Diego, California. Received B.A. from College of Creative Studies, University of California, Santa Barbara, 1969; M.F.A. from Villa Schifanoia, Graduate School of Fine Art, Florence, 1973. Lives in California.

Selected Individual Exhibitions

1971-1972 Touring Exhibition, four western provinces of Canada / 1973 Galleria Vives, Menorca, Balearic Islands, Spain / 1979 Art Gallery, Santa Barbara City College / 1980 Opus 5 Gallery, Del Mar / Art Gallery, California State University, San Bernardino / Art Gallery, California State University, Fresno.

Selected Group Exhibitions

1977 *Howard Warshaw, A Continuing Tradition,* UCSB Art Galleries, Santa Barbara / 1979 Opus 5 Gallery, Del Mar / 1981 *The Figure and its Postures,* Loyola Marymount University, Los Angeles.

Selected Reading

Fox, Louis W. "John Nava," *Artweek,* vol. 11, 12 April 1980, p. 4.

Haggerty, Gerard. "John Nava: Public and Private Realities," *Artweek,* vol. 10, 17 February 1979, p. 7.

Weisberg, Ruth. "The Posturing Figure," *Artweek,* vol. 12, 17 October 1981, pp. 3-4.

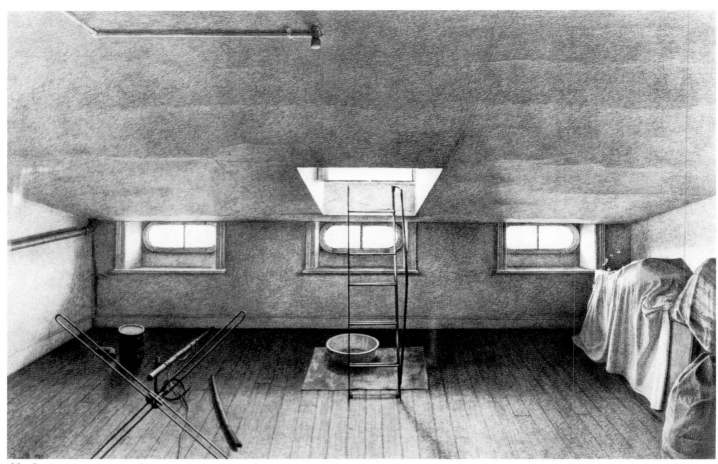

66 Paquette, *Attic III,* 1982

Gregory Paquette

Born 1947, Brooklyn, New York. Attended Brooklyn Museum Art School, 1972-1973; Art Students League, 1974; received B.A. from Hunter College, 1976. Lives in New York.

Selected Group Exhibitions

1978 *153rd Annual Exhibition,* National Academy of Design, New York / *1st Annual Exhibition,* Salmagundi Club, New York / 1981 *The Art of Drawing,* Staempfli Gallery, New York / 1981 *The Art of Drawing II,* Staempfli Gallery, New York / 1982 *Works on Paper,* Weatherspoon Gallery, University of North Carolina, Greensboro (catalogue).

Selected Reading

Cohen, Ronny H. "Drawing the Meticulous/Realist Way," *Drawing.* New York: The Drawing Society, vol. 3, March/April 1982, pp. 122-123.

Selected Reading

Cohen, Ronny H. "Drawing the Meticulous/Realist Way," *Drawing.* New York: The Drawing Society, vol. 3, March/April 1982, pp. 122-123.

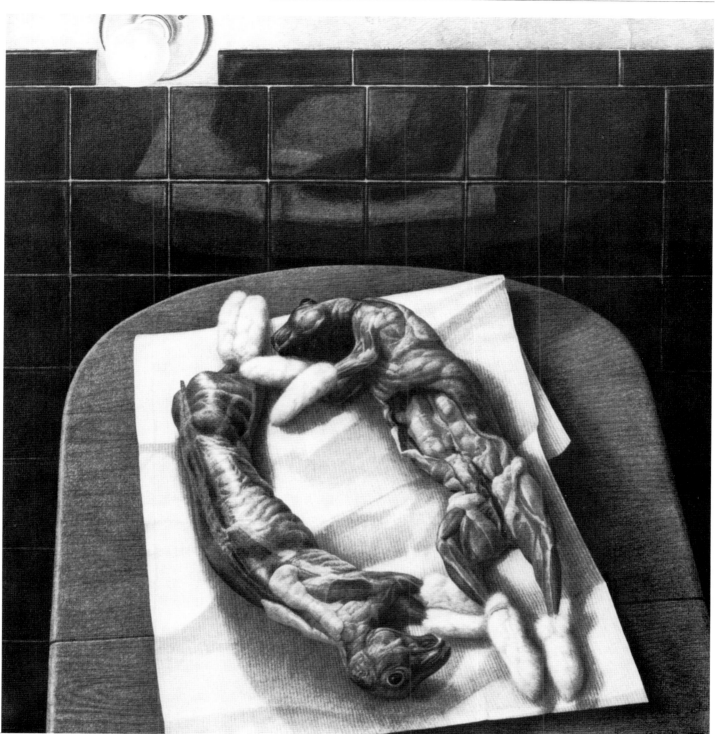

65 Paquette, *Flayed Rabbits,* 1981

67　Rubin, *Self-Portrait,* 1981

Sandra Mendelsohn Rubin

Born 1947, Santa Monica, California. Received B.A. 1976, and M.F.A. 1979, from University of California, Los Angeles. Lives in California.

Selected Individual Exhibitions

1982 *Selected Paintings and Drawings from 1980-1982,* L.A. Louver Gallery, Venice.

Selected Group Exhibitions

1977 *Images: Interior/Exterior,* Municipal Art Gallery, Los Angeles / *California Suite,* Los Angeles County Museum of Art / 1978 *15 Artists,* Los Angeles Institute of Contemporary Art / Los Angeles Contemporary Exhibitions / *National Invitational: Drawing/Painting 1978,* College Art Gallery, State University of New York, New Paltz / 1980 *Three Realist Painters: Maxwell Hendler, Richard Shaffer and Sandra Mendelsohn Rubin,* L.A. Louver Gallery, Venice / 1981 *Major Works by Six Artists,* L.A. Louver Gallery, Venice/ *California: The State of Landscape 1972-1981,* Newport Harbor Art Museum, Newport Beach (catalogue and tour) / Odyssia Gallery, New York / *Locations,* California State University, San Bernardino (catalogue) / *The Figure and Its Postures,* Loyola Marymount College, Los Angeles / *Elegant Night,* Security Pacific National Bank, Los Angeles (catalogue) / 1982 *Exhibition of Contemporary Los Angeles Artists,* Nagoya City Museum, Japan and Municipal Art Gallery, Los Angeles / *Drawings by Painters,* Long Beach Museum of Art (catalogue and tour) / *The Michael and Dorothy Blankfort Collection,* Los Angeles County Museum of Art (catalogue) / *The Real Thing,* Laguna Beach Museum of Art (catalogue).

Selected Reading

Askey, Ruth. "Double X Curates Woman's Show," *Artweek,* vol. 9, 29 July 1978, p. 15.

Fox, Louis. "Formalizing the City," *Artweek,* vol. 12, 24 October 1981, p. 4.

Gamwell, Lynn. "Southern California Realist Painting, *The Real Thing* (exh. cat.). Laguna Beach: Laguna Beach Museum of Art, 1982.

Muchnic, Suzanne. "A Dent in the Summer Blahs," *Los Angeles Times,* 7 August 1978, p. 6.

——. "Artists Get Foot in Door," *Los Angeles Times,* 2 June 1980, p. 1.

——. "Realism: A Summer Spread is Showing," *Los Angeles Times,* 11 July 1980, p. 10.

——. "Drawings by California Painters," *Los Angeles Times,* 16 February 1982, p. 1.

——. "L.A. Works on Exhibit via Nagoya, Japan," *Los Angeles Times,* 19 April 1982, pp. 1, 4.

Seldis, Henry. "Art: Local Talents," *Los Angeles Times,* 7 August 1977, p. 82.

Rosenthal, Adrienne. "Human Emanations," *Artweek,* vol. 11, 19 July 1980, p. 4.

Weisberg, Ruth. "Surveying Southern California Realist Painting," *Artweek,* vol. 13, 5 June 1982, p. 1.

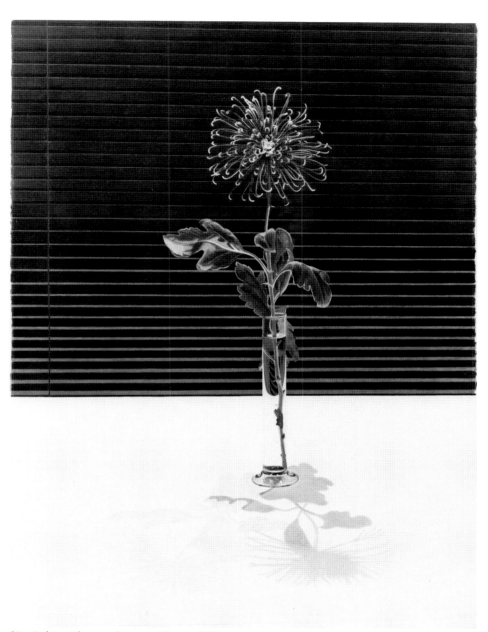

69 Rubin, *Chrysanthemum Flower,* 1982

71 Sherr, *St. Mark's Church,* 1980

Born 1952, Plainfield, New Jersey. Attended
Du Cret School of Art, Plainfield; received
Certificate from National Academy of
Design, New York, 1975. Lives in New York.

Selected Group Exhibitions

1976 *Seven Young Realists,* Baruch College,
New York / *Young Realists,* Harbor Gallery,
Cold Spring Harbor, New York / 1978 Far
Gallery, New York / *Childe Hassam
Purchase Fund Exhibition,* Institute of Arts
and Letters, New York / *Painting and
Sculpture Today,* Indianapolis Art
Museum / 1979 Doll & Richards Gallery,
Boston / *Drawing Exhibition,* University of
New Hampshire, Durham / 1981,
1982 Sindin Gallery, New York.

Ronald Sherr

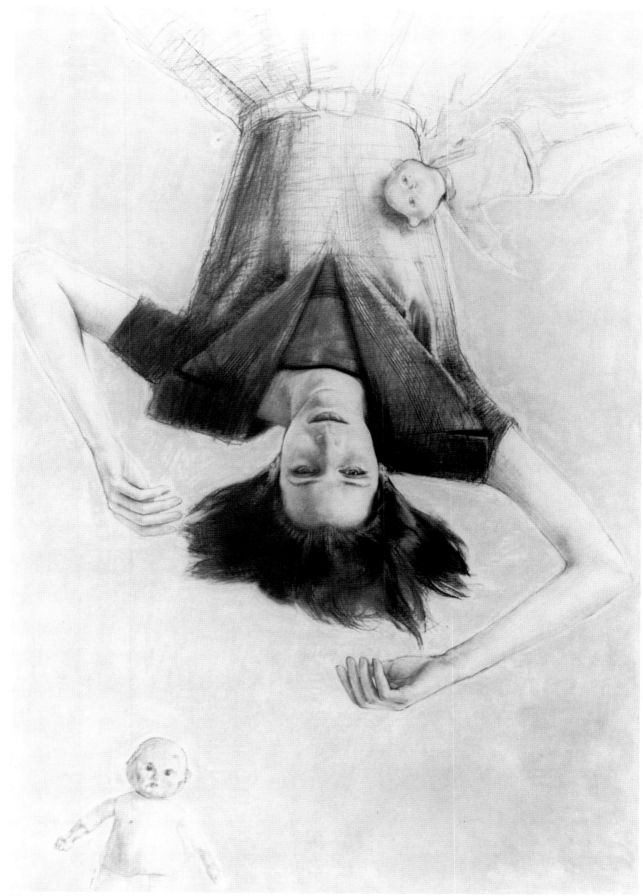

73 Sherr, *Betty's Babies,* 1981

76 Thiebaud, *Rock Ridge,* 1982

Wayne Thiebaud

Born 1920, Mesa, Arizona. Received B.A., 1951, and M.A., 1952, Sacramento State College. Self-taught artist. Lives in California.

Selected Individual Exhibitions

1952 Crocker Art Gallery, Sacramento / 1954 Artists Cooperative Gallery, Sacramento / 1957 Sacramento City College / 1962 M.H. de Young Museum, San Francisco / 1962, 1963, 1964, 1965, 1966, 1967, 1970, 1976, 1982 Allan Stone Gallery, New York / 1963 Galleria Schwarz, Milan / 1970 Crocker Art Gallery, Sacramento (catalogue) / *Wayne Thiebaud Retrospective Exhibition,* Phoenix Art Museum (catalogue and tour) / 1981 Santa Barbara Contemporary Arts Forum.

Selected Group Exhibitions

1969 *Aspects of New Realism,* Milwaukee Art Center (catalogue and tour) / *Pop Art Redefined,* Hayward Gallery, London (catalogue) / *Pearlstein, Thiebaud, Gallo,* Kent State University Gallery, Kent, Ohio / *American Sense of Beauty,* Philbrook Art Center, Tulsa (catalogue) / *West Coast Art 1945-1969,* Pasadena Art Museum (catalogue) / *Whitney Annual,* Whitney Museum of American Art, New York / 1970 *Kompass,* Stedelijk Museum, Eindhoven (catalogue) / 1971 *Contemporary Views of Man,* Hayden Gallery, Massachusetts Institute of Technology, Cambridge / *Corcoran Biennale,* Washington, D.C. / ROSC, Dublin / 1972 *Documenta V,* Kassel (catalogue) / *Topography of Nature,* Institute of Contemporary Art, University of Pennsylvania, Philadelphia / *Food,* Emily Lowe Gallery, Hofstra College, Hempstead / 1974 *Aspects of the Figure,* Cleveland Museum of Art / *Twelve American Painters,* Virginia Museum of Fine Arts, Richmond / *Contemporary Portrait Exhibition,* Lowe Art Museum, Coral Gables / *Eight from California,* National Collection of Fine Arts, Washington, D.C. / 1975 *Living American Artists and the Figure,* Museum of Art, Pennsylvania State University, University Park / 1977 *American Master Drawings and Watercolors,* American Federation of Arts (book and tour) / *Still Life, Recent Drawings and Watercolors,* Boston University Art Gallery / *Drawings of the 70s,* Society for Contemporary Art, Art Institute of Chicago / *Contemporary Pastels and Watercolors,* Indiana University Art Museum, Bloomington / 1980

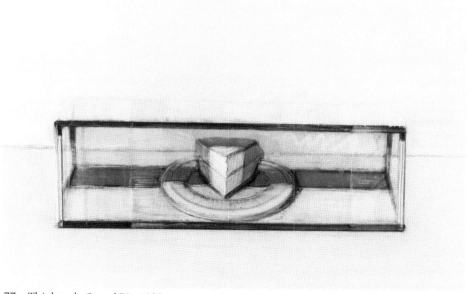

77 Thiebaud, *Caged Pie,* 1982

Realism/Photo-Realism, Philbrook Art Center, Tulsa (catalogue) / 1981 *Real, Really Real, Super Real,* San Antonio Museum of Art (catalogue and tour) / *Contemporary American Realism since 1960,* Pennsylvania Academy of the Fine Arts, Philadelphia (catalogue and tour).

Selected Reading:

Albright, Thomas. "Wayne Thiebaud: Scrambling around with ordinary problems," *ARTnews,* vol. 77, February 1978, pp. 82-86.

Cooper, Gene. *Wayne Thiebaud, 1947-1976* (exh. cat.). Phoenix: Phoenix Art Museum, 1976.

Cummings, Paul. "Interview, Wayne Thiebaud talks with Paul Cummings," *Drawing,* New York: The Drawing Society, vol. 4, July/August 1982, pp. 33-35.

Perrone, Jeff. "Wayne Thiebaud from Phoenix to Des Moines," *Artforum,* vol. 15, March 1977, pp. 42-45.

Stowens, Susan. "Wayne Thiebaud, Beyond Pop Art," *American Artist,* vol. 44, September 1980, pp. 46-51, 102-104.

Tooker, Dan. "Wayne Thiebaud," *Art International,* vol. 18, November 1974, pp. 22-25.

James Valerio

Born 1938, Chicago. Received B.F.A. and M.F.A. from School of the Art Institute of Chicago. Lives in New York.

Selected Individual Exhibitions

1971, 1972 Gerard John Hayes Gallery, Los Angeles / 1973 Tucson Art Center / 1974 Michael Walls Gallery, New York / 1977 John Berggruen Gallery, San Francisco / 1981 Frumkin and Struve Gallery, Chicago.

Selected Group Exhibitions

1969 *72nd Annual Chicago and Vicinity Show,* The Art Institute of Chicago (catalogue) / 1971 *Painting and Sculpture Today —1970,* Indianapolis Museum of Art / *American Portraits, Old and New,* Long Beach Museum of Art / 1973 *Separate Realities,* Municipal Art Gallery, Los Angeles (catalogue) / 1974 *Selections in Contemporary Realism,* Akron Art Institute / 1975 *Watercolors and Drawings, American Realists,* Louis K. Meisel Gallery, New York / 1976 *Imagination,* Los Angeles Institute of Contemporary Art / 1977 *Painting and Sculpture in California: The Modern Era,* San Francisco Museum of Modern Art (catalogue and tour) / 1979 *The Big Still Life,* Allan Frumkin Gallery, New York / *Uncommon Visions,* Memorial Art Gallery, University of Rochester, New York / 1980 *Realism / Photo-Realism,* Philbrook Art Center, Tulsa (catalogue) / 1981 *Real, Really Real, Super Real,* San Antonio Museum of Art (catalogue and tour) / *Inside Out,* Newport Harbor Art Museum, Newport Beach (catalogue and tour) / *Contemporary American Realism since 1960,* Pennsylvania Academy of the Fine Arts, Philadelphia (catalogue and tour) / *A Private Vision: Contemporary Art from the Graham Gund Collection,* Museum of Fine Arts, Boston (catalogue).

Selected Reading

Bell, Jane. "James Valerio," *Arts Magazine,* vol. 48, June 1974, p. 56.

Frank, Peter. "James Valerio," *ARTnews,* vol. 73, October 1974, p. 123.

Kramer, Hilton. "The Return of the Still Life," *The New York Times,* 4 March 1979, p. 29.

————. "Art: Five-Gallery Realist Show," *The New York Times,* 12 September 1980, p. C 20.

Martin, J. "A Conversation with James Valerio," *Newsletter.* New York: Allan Frumkin Gallery, no. 13, Fall 1981, pp. 1-3.

Moore, Sarah J. "Specificity, Particularity, and Objectivity in Realism," *Artweek,* vol. 12, 5 September 1981, p. 3.

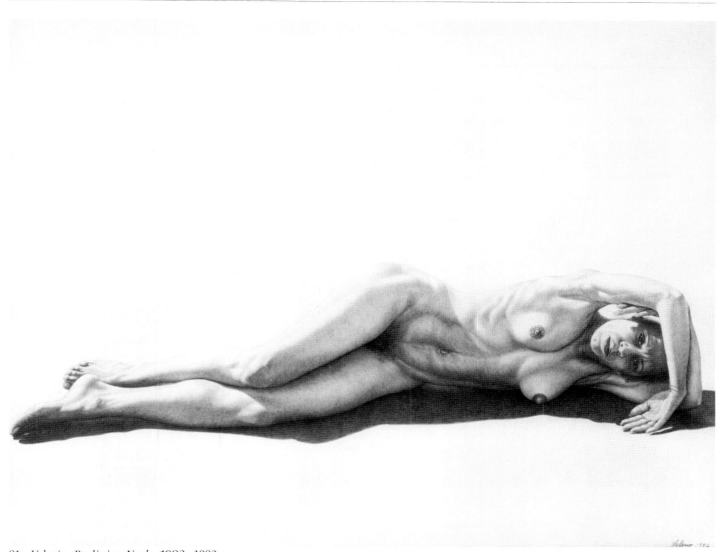

81 Valerio, *Reclining Nude, 1982* 1982

Selected Bibliography

Art in America, Special Issue: Realism, vol. 69, September 1981.

Arthur, John. *Realism/Photo Realism* (exh. cat.). Tulsa: Philbrook Art Center, 1980.

_____. *Realist Drawings and Watercolors.* Boston: New York Graphic Society, 1980.

Battcock, Gregory, ed. *The New Art.* New York: E.P. Dutton, 1966.

Coke, Van Deren. *The Painter and the Photograph.* Albuquerque: University of New Mexico Press, 1972.

Documents, Drawings and Collages/Fifty American Works on Paper from the Collection of Mr. and Mrs. Stephen D. Paine (exh. cat.). Williamstown: Williams College Museum of Art, 1979.

Farwell, Beatrice. *The Cult of Images, Baudelaire and the 19th-Century Media Explosion.* Santa Barbara: UCSB Art Museum, 1977.

Gombrich, E.H. *Art and Illusion.* Princeton: Princeton University Press, 1960.

Goodyear, Frank. H., Jr. *Contemporary American Realism since 1960* (exh. cat.). Boston: New York Graphic Society, 1981.

Greenberg, Clement. *Art and Culture.* Boston: Beacon Press, 1961.

Les Réalismes 1919-1939 (exh. cat.) Paris: Musée National d'Art Moderne, 1980. Introductions by Wieland Schmied, Jean Clair and Zeno Birolli.

Mathey, François. *American Realism.* New York: Skira/Rizzoli, 1978.

Nochlin, Linda. *Realism.* Harmondsworth, Baltimore and Ringwood: Penguin, 1971.

_____. "The Realist Criminal and the Abstract Law," Parts I and II, *Art in America,* vol. 61, September/October 1973, pp. 54-61, and November/December 1973, pp. 97-103.

Novak, Barbara. *American Painting of the Nineteenth Century.* New York: Praeger, 1969.

_____. *Nature and Culture, American Landscape and Painting 1825-1875.* Toronto: Oxford University Press, 1980.

Nygren, Edward J. *The Human Form/Contemporary American Figure Drawing and the Academic Tradition* (exh. cat.). Washington, D.C.: Corcoran Gallery of Art, 1980.

Ortega Y. Gasset. *Velazquez, Goya and the Dehumanization of Art.* Translated by Alexis Brown with Introduction by Philip Troutman. New York: W.W. Norton, 1972.

Porter, Fairfield. *Art in Its Own Terms, Selected Criticism 1935-1975.* Introduction by Rackstraw Downes, ed. New York: Taplinger, 1979.

Real, Really Real, Super Real (exh. cat.). San Antonio: San Antonio Museum of Art, 1981. Essays by Alvin Martin, Linda Nochlin and Philip Pearlstein.

Scharf, Aaron. *Art and Photography.* Harmondsworth, Baltimore and Ringwood: Penguin, 1974.

Stebbins, Theodore E., Jr. *American Master Drawings and Watercolors.* New York: Harper & Row, 1976.

Steinberg, Leo. *Other Criteria.* New York: Oxford University Press, 1972.

Weisberg, Gabriel P. *The Realist Tradition: French Painting and Drawing 1830-1900* (exh. cat.). Cleveland: The Cleveland Museum of Art, 1980.

White, Hayden. "The Culture of Criticism," *Liberations,* ed. Ihab Hassan. Middletown: Wesleyan University Press, 1971.